PARKGATE
& NESTON
THROUGH TIME
Vanessa Greatorex

AMBERLEY PUBLISHING

Over to You

No prizes for guessing where this is, but have fun trying to spot it when you're out and about exploring the area.

First published 2014

Amberley Publishing
The Hill, Stroud, Gloucestershire, GL5 4EP
www.amberley-books.com

Copyright © Vanessa Greatorex, 2014

The right of Vanessa Greatorex to be identified as the
Author of this work has been asserted in accordance with
the Copyrights, Designs and Patents Act 1988.

ISBN 978 1 4456 0899 0 (print)
ISBN 978 1 4456 3572 9 (ebook)

British Library Cataloguing in Publication Data.
A catalogue record for this book is available from the
British Library.

Typesetting by Amberley Publishing.
Printed in Great Britain.

Introduction

The market town of Neston is situated about halfway down the Wirral peninsula. Its name is derived from two Old English words meaning 'village on a headland', a reference to its once prominent position on the River Dee. A scattering of Roman and Irish-Norse artefacts found in its vicinity bear witness to the area's cosmopolitan past, and in the thirteenth century it attracted sufficient royal attention to merit a palisaded deer park. However, for much of its early history it was essentially a rural community at the heart of a sizable parish, whose townships included Little Neston and Ness (also featured in this book).

Neston's fortunes changed when its role as an outlying anchorage of the port of Chester expanded, siltation having affected the navigability of the Dee further up the river. Between the 1550s and the 1700s, ships transported passengers and freight between Neston New Quay and Ireland, France and Spain. Sadly, trade was lost first to Parkgate and then to the newly emerging port of Liverpool when, succumbing to the fate of Chester, Neston fell victim not just to siltation but also to the canalisation of the Dee in the 1730s. This improved the depth of the water in some places, but had a tendency to channel the river towards Wales rather than the south Wirral coast. The town's fortunes were not repaired until the construction of two railway lines linking Neston to Chester, Wales and other parts of Wirral.

A combination of coal mining, quarries, agriculture and commerce generated enough prosperity for a number of residents to spend their money on sturdy shops and houses, many of which are still in use today.

Nevertheless, times were not always easy. Cholera struck in 1866, and in 1908 one Neston resident noted, 'It is the harvest festival here today and most of the corn lying rotting for want of nice weather.' Other reports were more favourable. One visitor described it as 'A very nice little place', and, writing to relatives in Liverpool during the Second World War, the mother of a young evacuee said her daughter thought they were on a picnic and didn't want to go home.

The history of Parkgate is even more beguiling. When, at the dawn of the seventeenth century, ships began to take advantage of the deep anchorage near Neston's deer park, a small settlement grew up around the gates, and by 1610 it was being referred to as the Parkgate. Taking over from Neston, it suddenly found itself England's premier port for ships to Ireland. A shorter crossing could be had by embarking from Holyhead in Wales, but Parkgate was more accessible and for most passengers necessitated a much shorter journey by road.

Illustrious travellers passing through Parkgate on their way to and from Ireland included the composer George Frideric Handel, the writer Jonathan Swift and the Methodist preacher John Wesley. Later on, the artist J. M. W. Turner produced an engraving entitled *Flint from Parkgate*, featuring ships sailing on the Dee, with a field of Wirral corn in the foreground and Flint Castle and the Welsh hills beyond.

Sometimes bad weather or unfavourable tides left passengers kicking their heels in Parkgate for days or even weeks. To enliven their stay all manner of amenities were created, including

numerous inns, two assembly rooms, a theatre and a racecourse. Parkgate grew from a tiny hamlet into a fashionable resort, with a string of fine houses facing the river.

Because of the tidal nature of the Dee, its estuarine waters were salty not fresh, and carried the ozonic tang of the sea. As a result, the resort acquired the reputation for having a healthy atmosphere. This attracted even more visitors and led to a proliferation of small boarding schools. Meanwhile, ordinary folk plied their trade as mariners, fishermen, laundry maids and innkeepers.

The boom couldn't last forever. By the 1830s, siltation forced the Irish passenger trade to be transferred to Liverpool and Holyhead, but within a few decades trains were bringing holidaymakers and day-trippers back to Parkgate. High tides continued into the 1940s, but by the end of the decade the effects of siltation could no longer be halted, and marshland swallowed the river as far as the sandstone seawall. Despite this, Parkgate remains popular with day-trippers, and in 1955 a visitor said he found it 'very pleasant to be looking at the old places', adding, 'As far as I can see there's not a great deal of change up here except that the mud/sand of Parkgate is now a mass of green grass and weed.'

The settlement's remarkable history prompted the author Olive Dehn (1914–2007) to write *The Price of Shrimps*, an exciting and skilfully crafted short story about a fisherman's daughter, a sea-witch and the man who invented my name. This was my first introduction to Parkgate and spawned a lifelong fascination with its intriguing past, culminating in this book.

Acknowledgements

Many thanks to all the photographers of the vintage pictures and for everyone who helped me source them, particularly Paul Mitchell of Millcats Postcards, Ian Boumphrey, Norma Greatorex, Gavin Hunter and the wonderful staff of Cheshire Archives and Local Studies. Thanks, too, to my brilliant photographic assistant, Rosanna Roskilly; June Kirwin for lifelong access to *The Price of Shrimps*; Stephen and Alexander Roskilly for kindly giving their opinions, but only when invited; Bernard and Enid Rose for the laughs and tips; Anthony Annakin-Smith for sharing his encyclopaedic knowledge of Parkgate and Neston; Constables Estate Agents for the map; Jim McBurney and Sandra Harris of Backwood Hall; the ladies of Neston Bowling Club; Julia Skinner of The Francis Frith Collection; Tom Furby and Elizabeth Watts of Amberley; and everyone who knowingly or otherwise added colour to my photographs at the crucial moment.

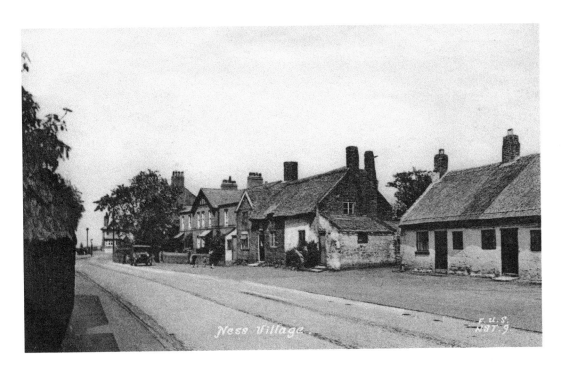

Ness Village

Ness: Cottages

Swan Cottage in the village of Ness was the birthplace of Amy Lyon, a smith's daughter, who became an actress and married a lord before achieving lasting fame as Lady Emma Hamilton, the mistress of Admiral Lord Nelson. Smithy Close now stands on the site of the thatched cottage in the picture, but Swan Cottage survives to this day. The pub in the distance was traditionally called The Wheatsheaf but has now become The Inn at Ness. Its unusual sign bears a painting of a lively looking fish.

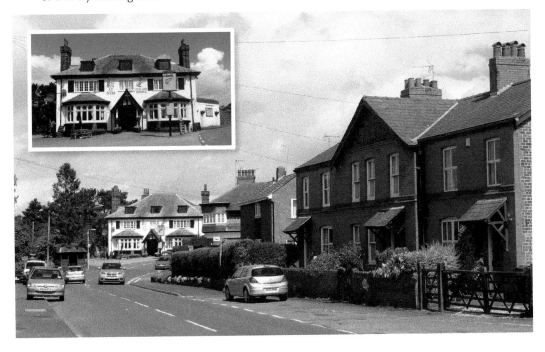

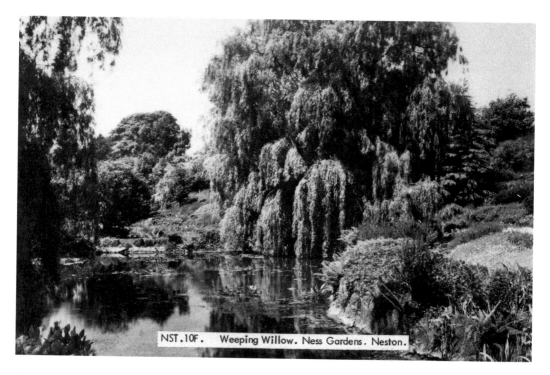

NST.10F. Weeping Willow. Ness Gardens. Neston.

Ness Botanic Gardens

In 1898, the Wirral-born cotton-broker Arthur Kilpin Bulley had a house called Mickwell Brow built on a sandstone outcrop near the village of Ness and set about using the surrounding land to indulge his passion for growing exotic plants. Missionaries, consuls and professional plant collectors were commissioned to source specimens from South America, Africa, and the Far East, and samples were exchanged with the Royal Botanic Gardens at Kew and Edinburgh. Today, the legacy of carefully planned landscapes incorporates such features as a grass labyrinth and a picnic lawn with glorious views of the Welsh hills.

Ness Botanic Gardens

During the Second World War, most of the groundsmen were called up, leaving only Head Gardener Josiah Hope and Ness-born First World War veteran Bill Cottrell to tend Bulley's Gardens (as they were then known locally). In the meantime, Bulley's seed and plant business, A. Bee & Co. (named from his initials), had moved from Ness to Sealand Road in Chester. Six years after Bulley's death in 1942, the 64-acre botanic gardens were donated with a £75,000 endowment to Liverpool University by the founder's daughter Lois and are now home to the National Collection of Sorbus and the University's weather station, as well as pine woods, water gardens and a wildflower meadow.

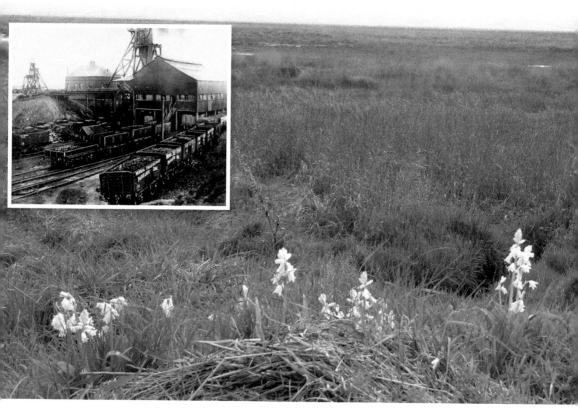

Neston: Neston Colliery

Ness was the location of the parish's first colliery, which operated from 1757 to 1855. The later workings shown above were at Little Neston. In the nineteenth century, fierce disputes raged between the rival mine owners, Sir Thomas Stanley of Ness and Thomas Cottingham of Little Neston. Ironically, the coal was poor quality and a network of galleries had to be dug beneath the River Dee to reach the Flintshire coal beds. Now the machinery has long gone, and the marshes have regained their tranquillity. Nature always wins in the end.

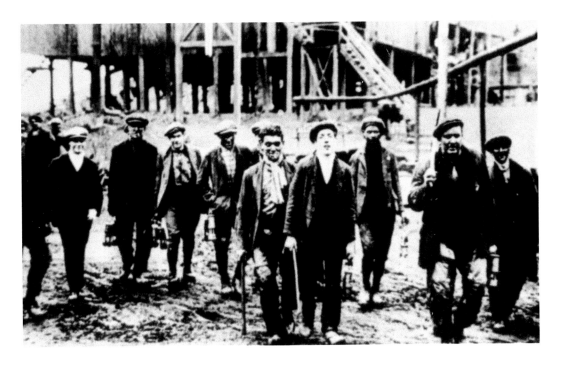

Neston: Colliery

The poignant picture above was taken in 1928 to record the last ever shift at Neston colliery. Two years earlier, during the General Strike of 1926, Mrs Bulley, the philanthropic wife of the founder of Ness Gardens, paid for the starving miners' families to receive provisions from local shops according to need. There was no safety net in place when the entire workforce was made redundant. Today, the area's industrial heritage is commemorated by some of the street names on the estate built near the old mines.

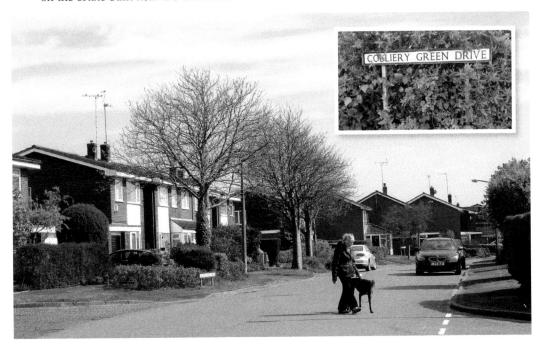

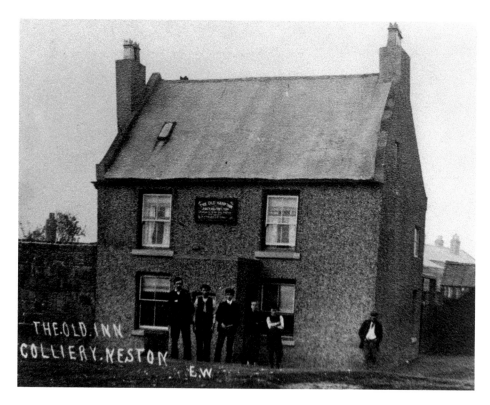

Little Neston: Harp Inn

Located near the quayside, The Old Harp Inn was the favoured watering hole of the miners from Neston collieries, many of whom were Welsh – hence the choice of name. John Palfreyman, who died in 1918, was the landlord when the above picture was taken. E. W., who wrote on the photograph, was probably a member of the prominent Whineray family of Leighton Court.

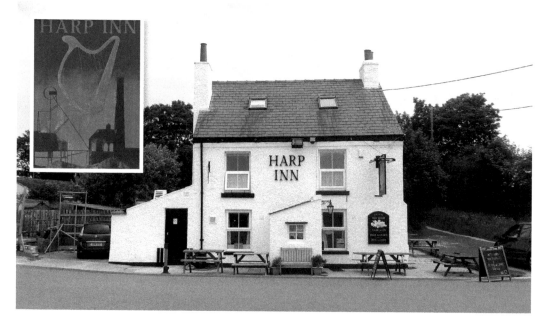

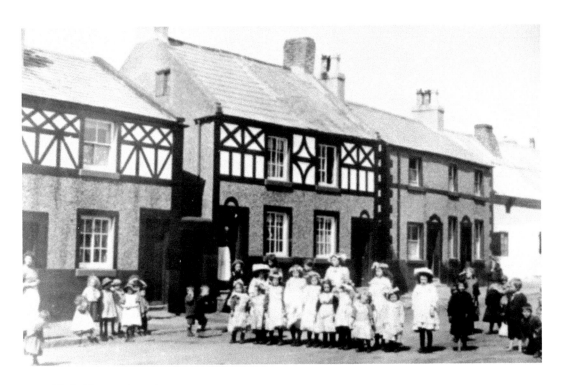

Little Neston: Lees Lane

The attractive houses behind the children fronted onto the village green when the above photograph was taken in around 1910. After demolition, they were replaced by retirement flats. On the other side of the green, however, Hope Cottages, proudly bearing the date 1853 and modernised in 1975, remain sought-after homes to this day.

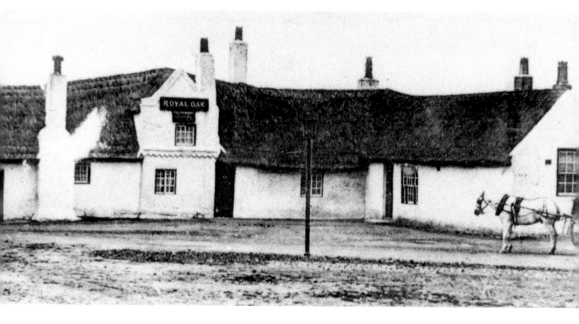

Little Neston: Royal Oak

William Burkey was the landlord of the Royal Oak when the above picture was taken around 1890, and it is his horse and trap that are visible on the right. He was also a builder, which must have stood him in good stead when the pub burned down in 1901. Situated directly opposite the village green, its two-storey replacement has undergone a few changes since rising from the ashes, and is associated with local pub football teams and live music as well as food and drink.

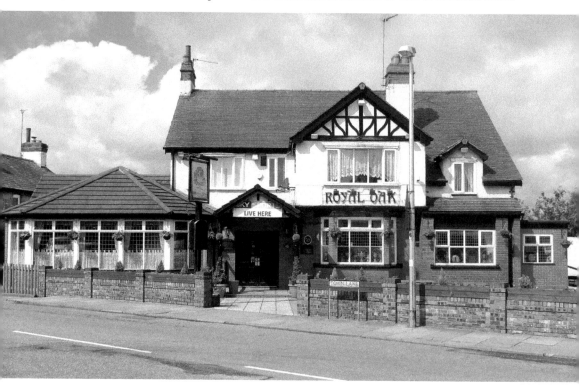

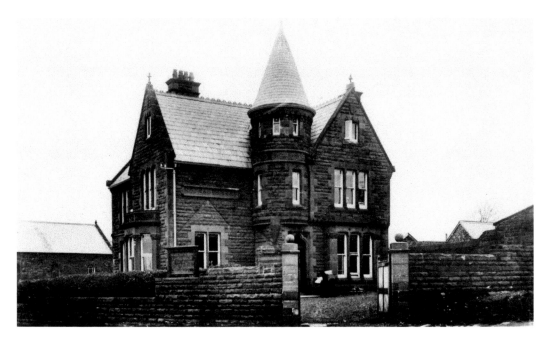

Little Neston: Neston Cottage Hospital/the Green

Not far from the green, Neston Cottage Hospital began life as Dee View, a magnificent sandstone house constructed by local builder William Pritchard for his own use. After the closure of the Red Cross Hospital at Neston Institute, Pritchard's home was converted into a hospital as a tribute to the ninety-one Neston servicemen who gave their life during the conflict. Lord Leverhulme opened it in June 1920, when it had nineteen beds. A wing containing twelve more beds was added in 1928 (after the above photograph was taken), and management was handed over to the National Health Service in 1948. Sadly, the building was sold at auction in 1964 and demolished three years later.

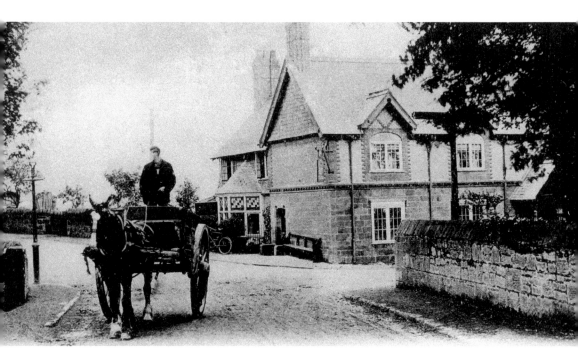

Neston: Hinderton Arms

Ideally located to refresh thirsty travellers at the crossroads to Chester, Hoylake, Neston and Willaston, the Hinderton Arms was originally known as the Shrewsbury Arms after its first owner, the Earl of Shrewsbury. It was mentioned in the Turnpike Act of 1826, when the landlord was John Robinson. Other nineteenth-century landlords included a vet and a farmer. From 1854, it occasionally served as the venue of Wirral Hundred Court, which was abolished two years later by Act of Parliament because of corruption and injustice. Nowadays, the focus is firmly on food and drink.

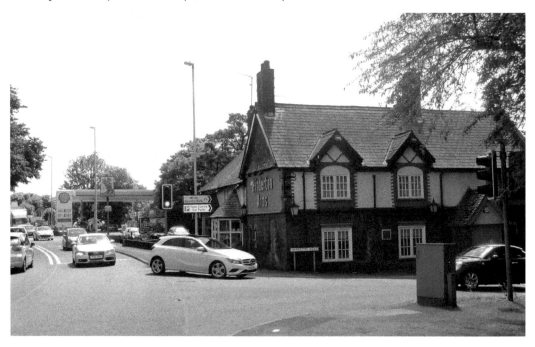

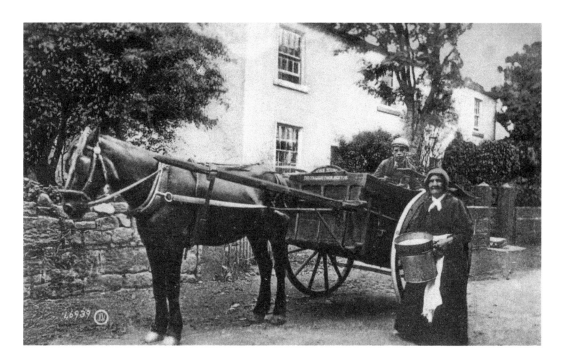

Neston: Chester High Road

These cottages stand diagonally opposite the Hinderton Arms on Chester High Road (now billed on road maps and signs as the A540). Most of their front gardens had to be sacrificed when the road was widened, and the owner of the end cottage chose to abandon the whitewashed finish in favour of the original red sandstone. The Victorian milk cart belonged to John Young, who owned Colliery Farm in Little Neston. Hale and hearty from a lifetime of lifting churns, the milkmaid was reputedly in her eighties.

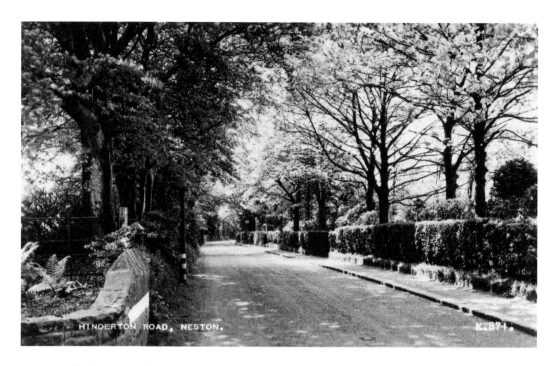

Neston: Hinderton Road

Hinderton literally means 'the back part of the town', and although Hinderton Road is the route by which many motorists reach Neston today, in 1621, when the name was first documented, passengers arriving by Moorside Road or the river would indeed have considered this part of Neston a hinterland. Lined with trees and linking Neston with the A540 Chester High Road, it has changed remarkably little in the sixty years that separate these two photographs.

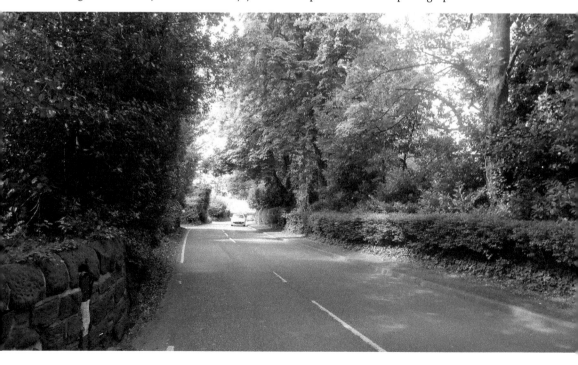

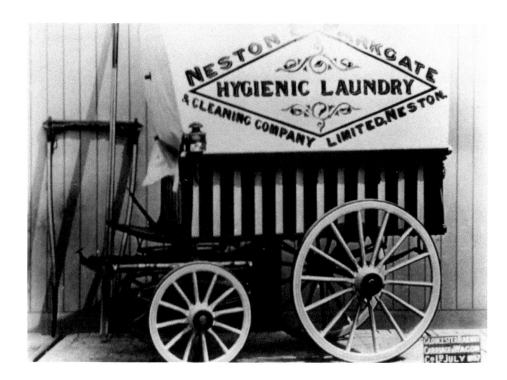

Neston: Cleaning Clothes

In its heyday, eighty people worked for the Neston & Parkgate Hygienic Laundry & Cleaning Company, which was one of the first businesses in the area to have a telephone, its number being Neston 26. An artesian well in Old Quay Lane provided clean water, which was discharged after use on to the marshes, leaving stagnant suds when the tide receded. The cart used for collections and deliveries was made by the Gloucester Railway Carriage & Waggon Co. Ltd in July 1897. People may have to take their clothes to the dry cleaner's themselves nowadays, but at least ethical business practices have cut down on pollution.

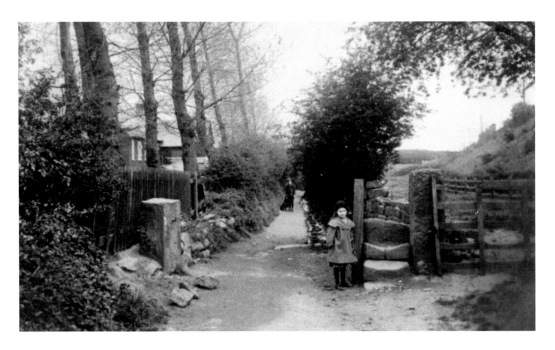

Neston: Stanney Fields Park

A tract of land known as Stanney Fields was given to Neston Urban District Council by the second Lord Leverhulme in 1935 for use as a public park. Family fun days, jazz evenings and dog shows are held there, and the Friends of Stanney Fields Park have helped it win Green Flag status for eight years in succession. Visible through the trees on the left in the vintage picture of *c.* 1900 is the Congregational chapel, which closed in 1938. The land was acquired by the Neston branch of the Royal British Legion in 1946, but the hedge is now too thick to see its two-storey premises from this angle.

Neston: Stanney Fields Park

Right from the outset, providing recreational facilities for the under-fourteens was a priority when designing the park. The 1930s concept of a simple playing field has now been bettered by the popular scooter ramps and playground equipment, and there are also plenty of places to stroll among greenery.

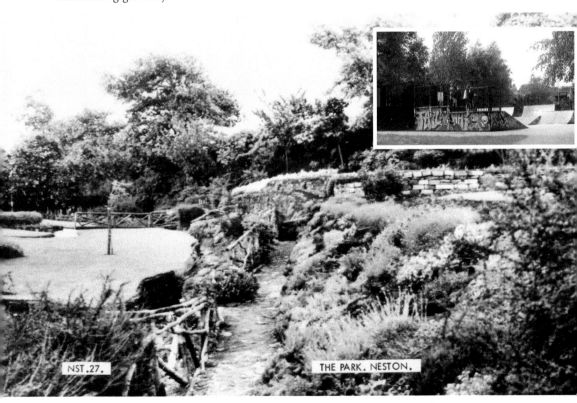

NST.27.

THE PARK, NESTON.

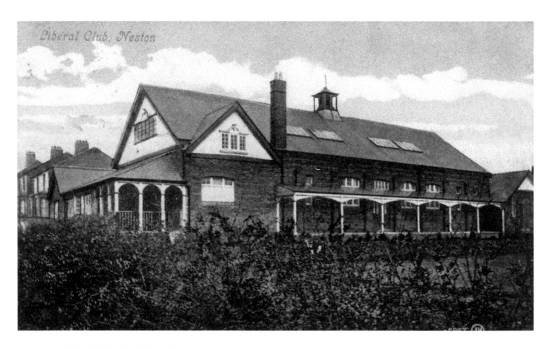

Liberal Club, Neston

Neston: Liberal Club/Civic Hall

Sunlight Soap magnate and Liberal MP William Hesketh Lever, later the first Lord Leverhulme, funded the construction of Neston's £3,000 Liberal Club on Hinderton Road. When the verandahed premises opened in 1902, the reputed capacity was 900 people. Outdoor sporty types could make use of its two tennis courts and bowling green, while indoor facilities included billiard tables, a reading room, and hot baths – a popular amenity in the days before modern plumbing became the norm in every home. Currently known as the Civic Hall, the building is shown below decked out with bunting for the Bicentenary of Neston Ladies' Day on 5 June 2014.

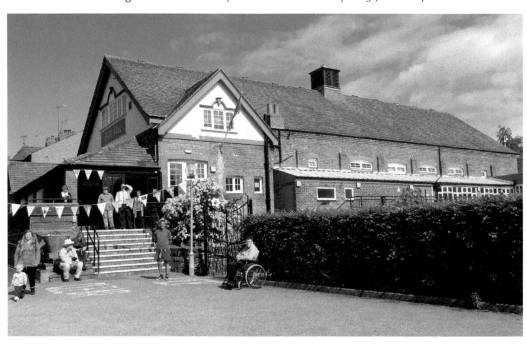

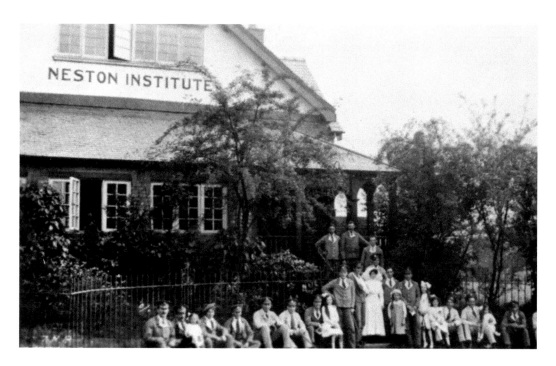

Neston: Neston Institute/Civic Hall

In 1908, the Liberal Club was renamed Neston Institute and went on to become a venue for films shown by the Neston Picturedrome Company. During the First World War, the building was dragooned into service as a Red Cross hospital, and film fans had to decamp to screenings at the town hall. The hospital closed in 1919, and the hall reverted to its former use as a community centre. Neston Flicks has now revived the hall's role as a makeshift cinema, and its stage is used for theatrical productions by the Neston Players.

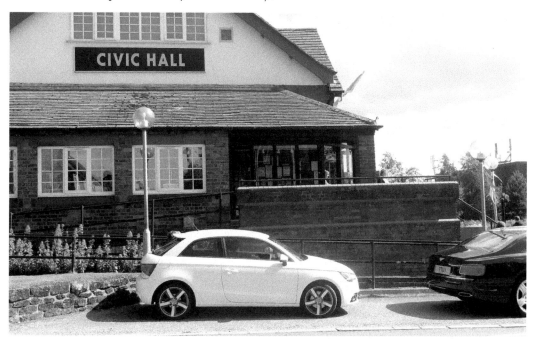

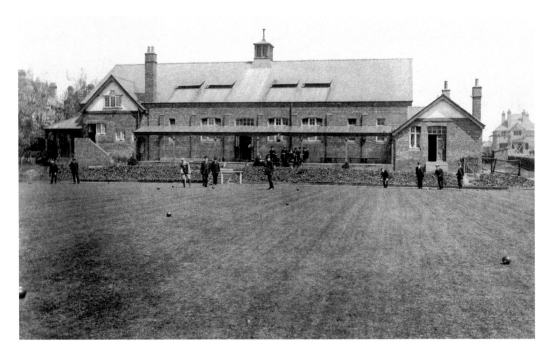

Neston: Bowling Club

Although there have been a few alterations to the adjacent Civic Hall, the bowling green beside it has changed little since being laid in 1902. At club level, however, the sport was usually the preserve of men, who played in everyday dark suits and hats. Now there are four teams based at Neston: two composed of veterans and one each of ladies and mixed, all expected to sport team colours at competitive fixtures.

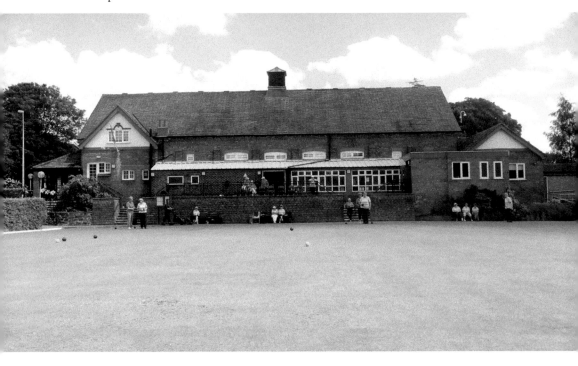

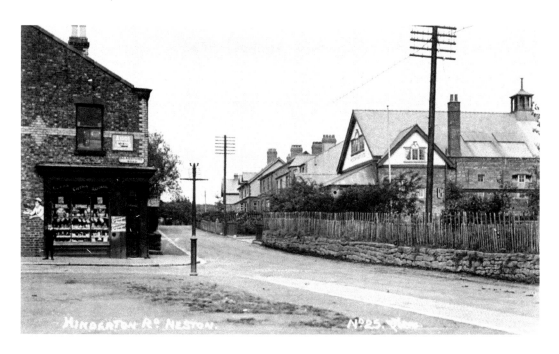

Neston: Corner of Gladstone Road

Now its proprietor repairs shoes, but in 1913 the shop on the corner of Hinderton Road and Gladstone Road was an ironmonger's. The houses in Gladstone Road were built by Liverpool developer James Thompson in the 1880s. The prominent Gladstone family had several connections with the area. The Victorian Prime Minister William Ewart Gladstone dug the first cut of the Bidston to Wrexham railway line, which ran through Neston. His son, Henry Neville Gladstone, lived at nearby Burton Manor, and during the First World War his daughter-in-law Maud ministered to wounded soldiers at the Convalescent Home in Parkgate.

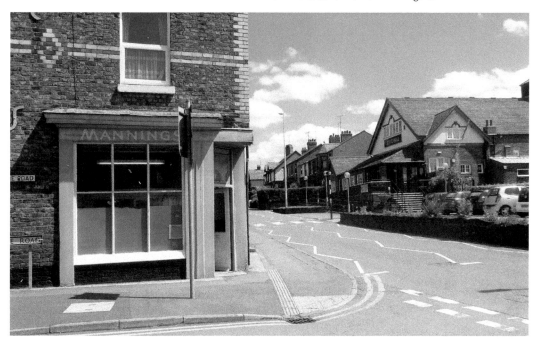

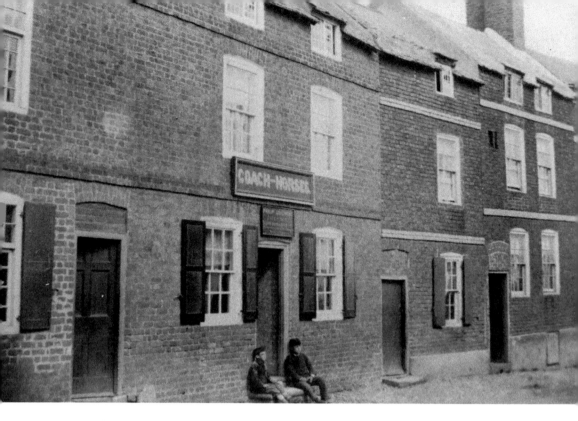

Neston: Coach and Horses

In its heyday as a port and market town, Neston was linked to London by a regular stagecoach service, and carriages from Chester and the Wirral added to the bustle. The Coach and Horses, in Bridge Street, was in a prime location for tending to the needs of all these passengers, but by the early twentieth century the town's fortunes had declined so much that, apart from its lacklustre sign, the pub had become barely distinguishable from the other terraced houses in the street. It's spruced up beautifully in its current guise as a Greek taverna.

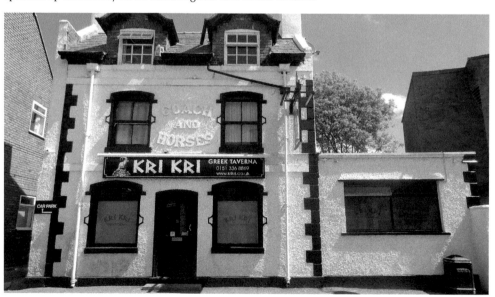

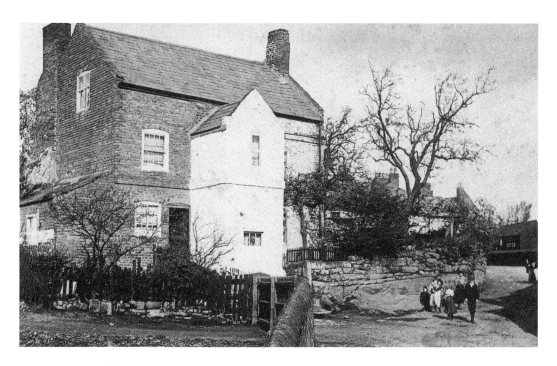

Neston: Bridge Street

Long since demolished, this house on Bridge Street was once owned by a Mr P. Bridson, who was also the proprietor of Bridson's Yard, located beyond the wall on the left. In the 1890s, he owned a sawmill and was also involved in supplying steam-powered machinery for threshing and ploughing. He even turned his hand to manufacturing bone manure. The flats of Steeple Court are now on the left of the road and more flats are located at Bridge Court beyond the cars.

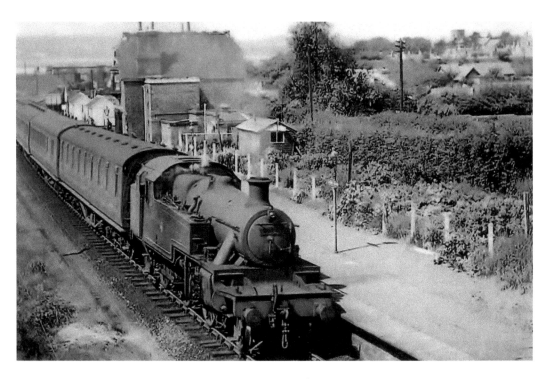

Neston: Station

For sixty years, Neston had two railway stations because it was served by two railway lines. Neston South, in Station Road, on the Hooton to West Kirby Line, was open to passengers from 1866 to 1956 – coincidentally, the date when this steam engine passed through the town. One of the primary motivations for opening the line was to transport coal from Neston colliery. Freight trains continued to use the line until 1962. It was then dismantled to create Britain's first country park. The adjacent stationmaster's house was uninhabited until 1970 but has since been demolished to make way for modern housing.

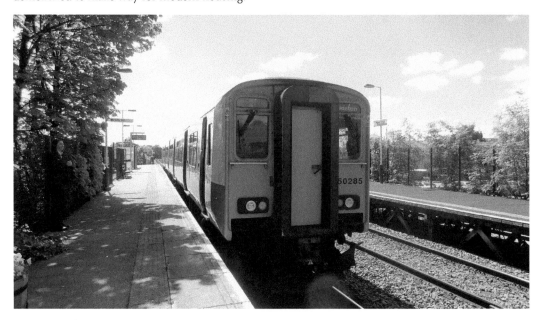

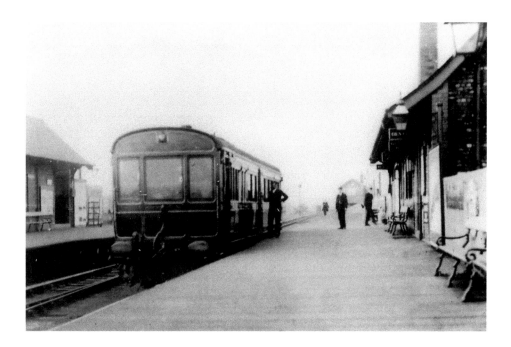

Neston: Station

Neston North station opened in Raby Road in 1896. It was served by the Bidston to Hawarden Bridge line, one of whose main functions was to carry raw materials and finished goods to and from Shotton Steelworks. The above picture shows Neston North in 1906, when it was fully staffed, with a ticket office and enclosed waiting rooms on both platforms. Trains between Bidston and Wrexham still halt there, but now the station is unmanned and the shelters are considerably more open. As for Station Road across the other side of town, it now leads to a small car park instead of a railway track – a confusing anomaly that only makes sense once Neston's transport history is known.

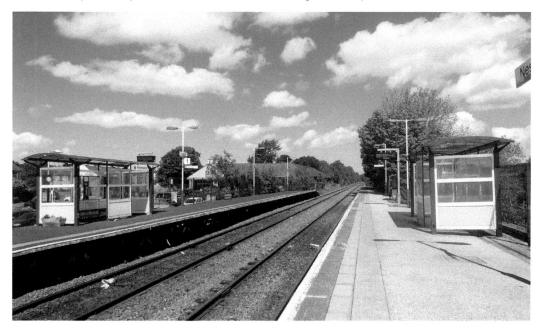

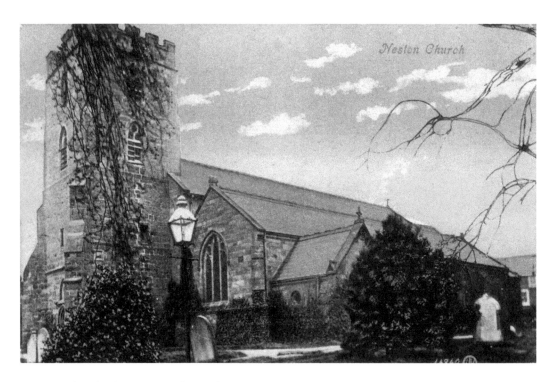

Neston: Church of St Mary and St Helen

The remains of grave crosses dating from AD 930 suggest that the site of St Mary and St Helen's has been a place of Christian worship for over a thousand years. The twelfth-century Norman church was replaced in 1874 with the current building. Constructed in the Gothic Revival style, it has several stunning stained-glass windows designed by the peerless Pre-Raphaelite artist, Edward Burne-Jones. In the last hundred years, the holly bush on the left of the hand-tinted vintage picture has grown into such a big tree that it's impossible to photograph the church properly from the same angle as the Edwardian photographer.

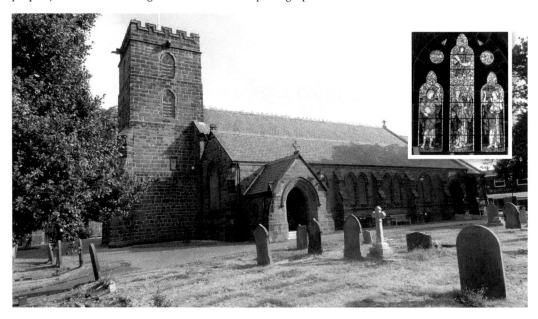

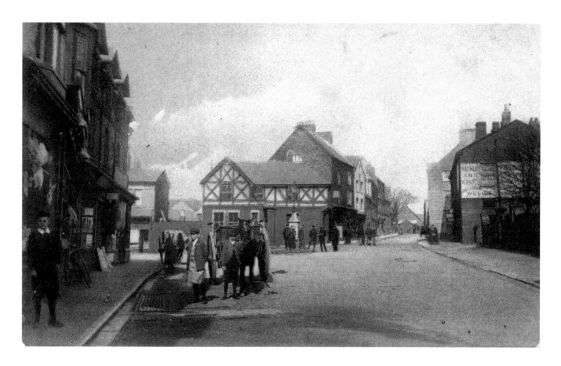

Neston: High Street and Cross

In Edwardian times, no respectable person went out without a hat, but, with only horse-drawn carts in the vicinity, it was perfectly acceptable to loiter in the middle of the road passing the time of day with like-minded idlers. The boy on the pavement is standing by some shops built by a local brewer called Thomas Whittell. A plaque bearing the date 1724 and the letters T/M (the initials of himself and his wife Margery) is on the central bay.

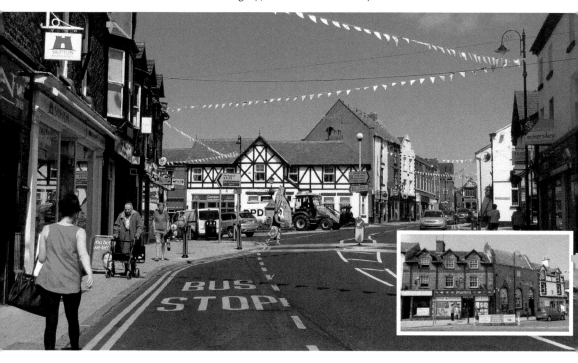

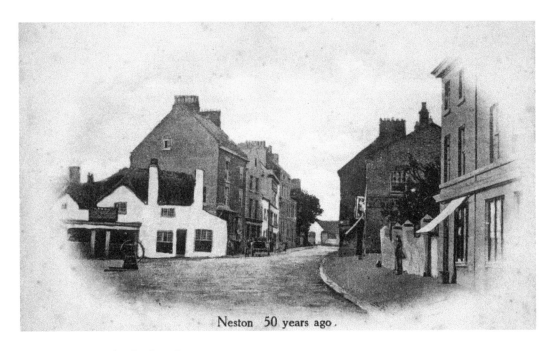

Neston 50 years ago.

Neston: Cross and Wheel Well

Add a one in front the '50' and you've probably reached the right era. The wheel well in the centre of Neston Cross (the local name for the crossroads) was donated to the community by local magistrate Christopher Bushell in 1865. Unfortunately, contaminants from drains and middens seeped through the porous sandstone, making the water unfit to drink, so it stopped being used for this purpose months before cholera hit Neston the following year. The thatched building behind the well is a pub called the White Horse, which was demolished in 1877. Its replacement survived a licensing purge in 1904, but time was finally called in the 1960s, and the building is now shared by an estate agent and a firm offering financial advice.

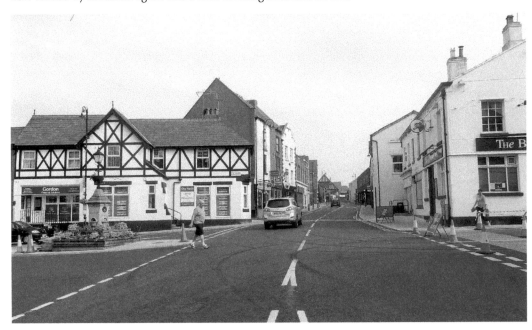

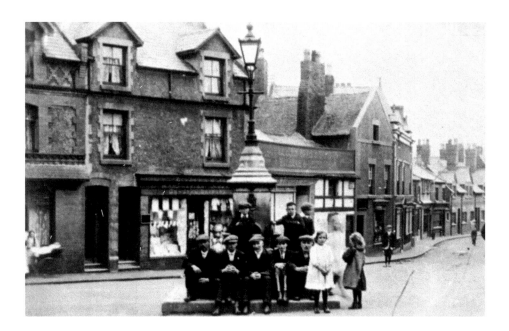

Neston: Cross and Parkgate Road

Although the wheel well was not a resounding success, its donor was assiduous in the service of the community, giving money for schools, roads and sanitation, and chairing fifteen committees and boards until his death in 1887 at the age of seventy-six. To mark his contribution, the Bushell fountain was erected on the site of the well in 1882. It was a popular meeting place when the roads were quieter, but was shifted closer to Parkgate Road in spring 2014 to improve traffic flow. The gabled building on the right, at the top of Parkgate Road, is the Greenland Fishery Hotel – successor of a sixteenth-century inn. It was amalgamated with its next-door neighbour, another pub, in 1892, spawning a rhyme that began: 'Black Bull, chucked and stranded, Green fish safely landed.'

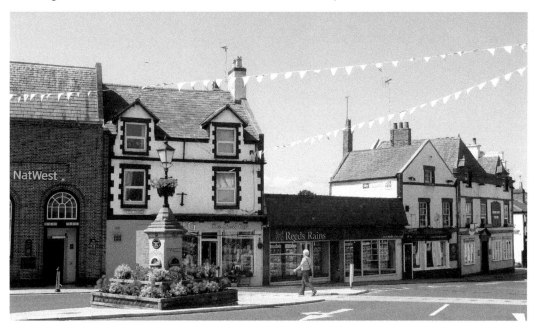

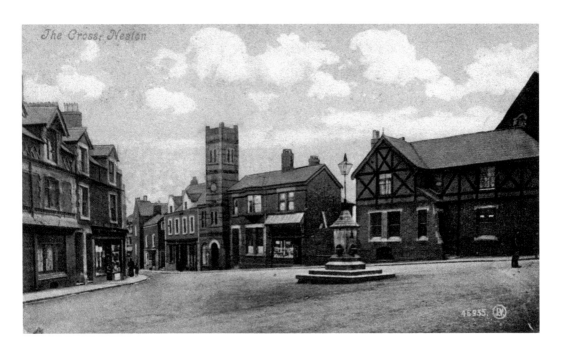

The Cross, Neston

Neston: Jackson's Tower

In Victorian times, Neston's post office moved premises several times, but was usually situated near the Cross. George Jackson was postmaster from 1890 until his wife Ada took over in 1912. He also ran the pharmacy, but was clearly interested in a life beyond commerce, because he conceived a wild fancy to build a tower next door to his shop. Constructed of red Ruabon brick, it was finished in 1895 and originally had a clock face on the front. Apparently oblivious to these glories, the 1909 sender of the vintage postcard depicting the above scene was more interested in telling its recipient that she was busy making marmalade.

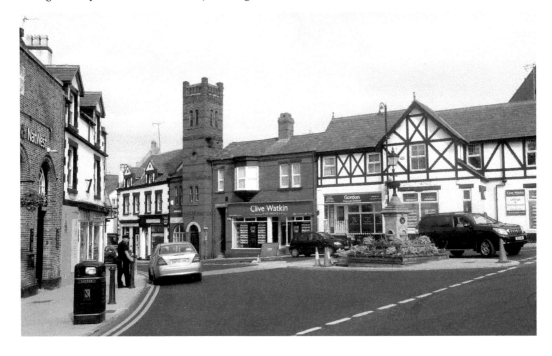

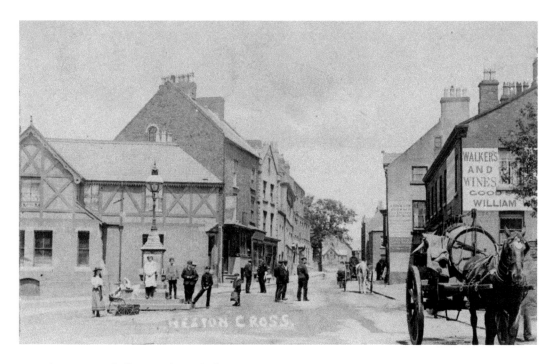

Neston: Bushell Fountain and The Brown Horse

Now you see it; now you don't. Since being moved further towards Parkgate Road, the Bushell fountain is no longer in photographic range from this perspective. Although it was connected to the piped water mains and therefore much safer to use than the ill-fated wheel well, there was still a place for horse-drawn water carts at the beginning of the twentieth century. The building in the foreground is The Brown Horse, constructed in the late nineteenth century to replace a 1724 pub of the same name. David Cottrell was its landlord in 1850. Now it's particularly known for live music.

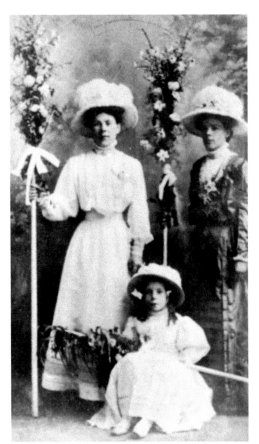

Neston: Ladies Day

Adopting as its motto 'Bear ye one another's burdens', the Neston Female Friendly Society was formed in 1814, when poverty was rife and a helping hand in times of especial need could tip the balance in favour of survival. The money raised from subscriptions created a bank of funds which could be dispensed to members who were struggling to cope when ill, infirm or bereaved. Although similar societies were formed up and down the country, all have now fallen by the wayside, leaving Neston to wave the last remaining banner. This is done with aplomb every year on Neston Ladies Day – the first Thursday in June, when members of all ages, holding beribboned white staffs topped with flowers, process through the town, led by a band.

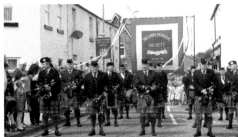

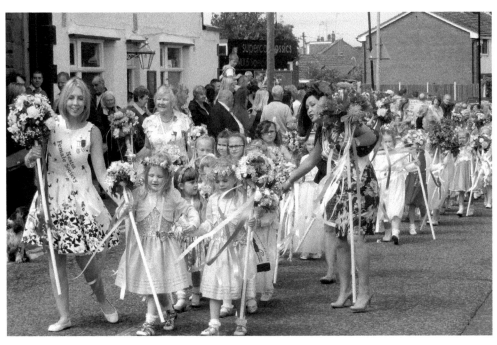

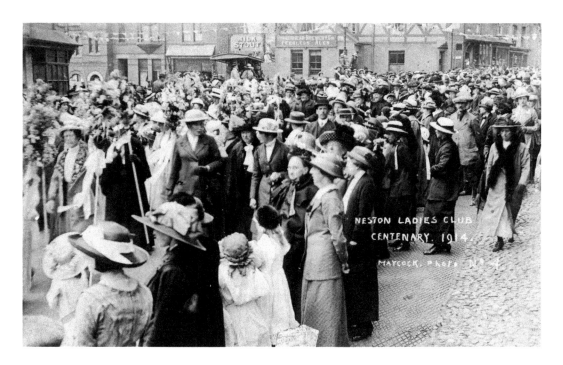

Neston: Ladies Day Centenary and Bicentenary

After a midway service in the parish church, the circuit around Neston traditionally continues to the Cross, where hymns are sung and prayers said. It is striking that in the centenary photograph of 1914, most people at the Cross were soberly dressed women. A hundred years later, a huge crowd of onlookers gathered to celebrate the bicentenary, their sense of history augmented by the Neston Players' moving new play, *A Walk Through Time*, which had premiered to packed audiences the previous week. For the first time ever, a special platform was set up by the Cross for the vicar and choir, and there was a conspicuous police presence, though mannerly behaviour was the order of the day.

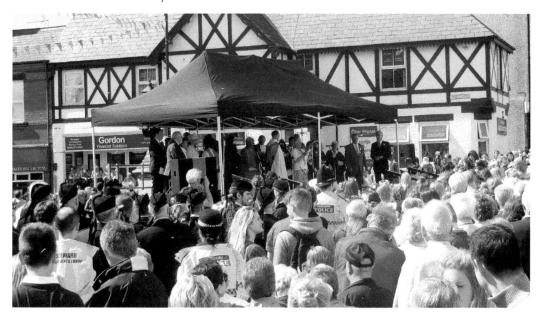

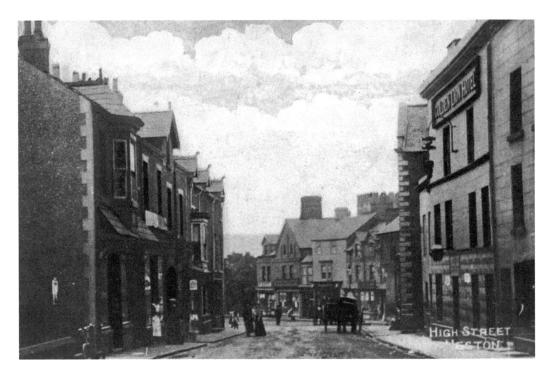

Neston: High Street

On the right of this hand-tinted postcard of Neston's High Street, the Golden Lion Hotel can be seen. The bowling green behind it was the headquarters of Neston's bowling club from 1892, and became a popular venue for raucous dances on Neston Ladies Day. In 1905, perhaps as a result of its reputation for occasional rowdiness, the Golden Lion permanently lost its licence during a government initiative to cut down on alcohol abuse. Shops and flats now occupy that side of Neston's High Street. There have also been many building alterations on the other side, with only two of the four jutting gables remaining.

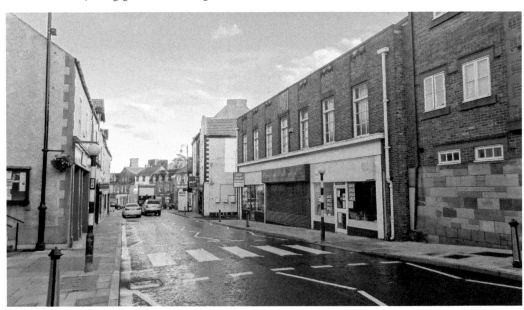

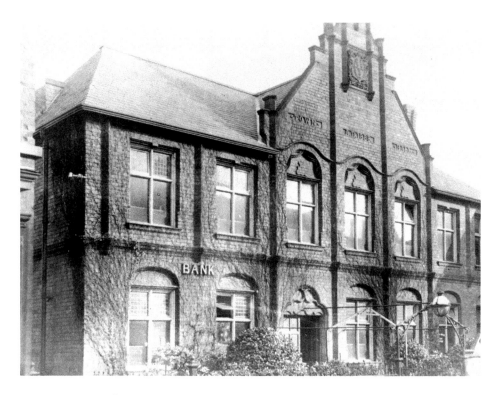

Neston: Town Hall

Neston Town Hall was designed by Wirral architect David Walker, and constructed by local builder William Pritchard on the High Street in 1887/88, at a cost of £2,000. The carving of three wheatsheaves at the top – adopted as the emblem of Cheshire by the local council – was inspired by the heraldic device of Ranulf de Blundeville, 6th Norman Earl of Chester (1170–1232). As well as housing Neston Town Council, it is now home to the post office.

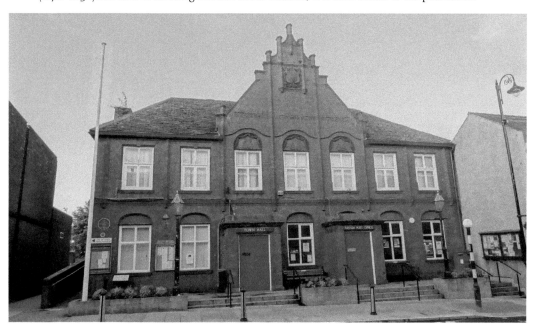

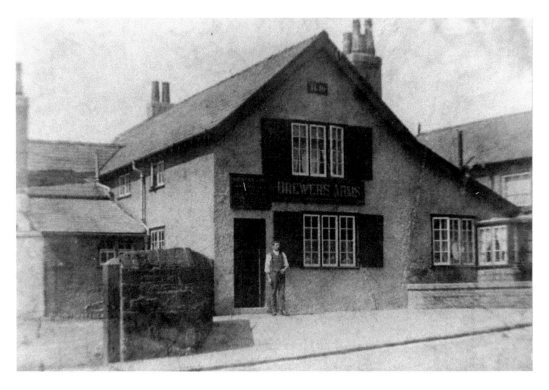

Neston: Brewers Arms

There has been a pub called the Brewers Arms on the same site in Neston since 1670. According to *Bagshaw's Directory*, the landlord in 1850 was William Cross, but the identity of the man in the slightly later photograph above is less certain. The building itself has changed remarkably little over the last century. Supplementing the bill of fare, activities on offer today include pool, poker, charity quiz nights and live music.

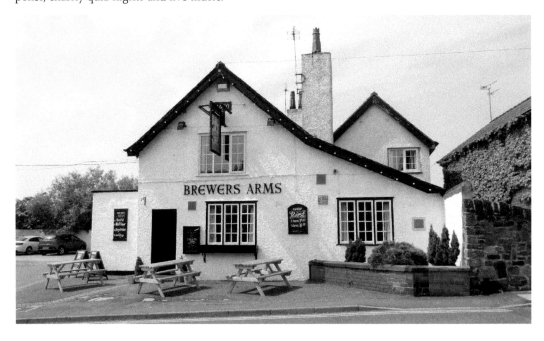

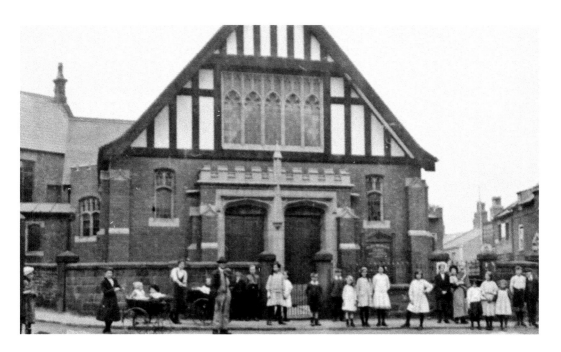

Neston: Methodist Church

Neston's Methodist church – previously known as the Wesleyan chapel – stands at the intersection of High Street and Park Street and also serves as a multi-purpose community centre. Its foundation stone was laid on 27 June 1908, when enough money had been raised to replace the corrugated-iron mission hall, which had been there since 1874. Before that, a small, thatched butcher's shop called Youd's occupied the site. The picture above is believed to have been taken in 1917. No documentation explains why all the children were standing outside, but they were probably members of the Sunday school.

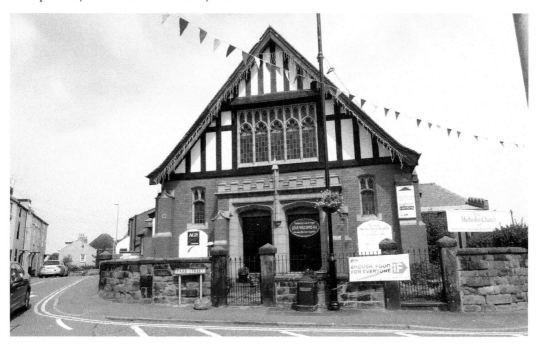

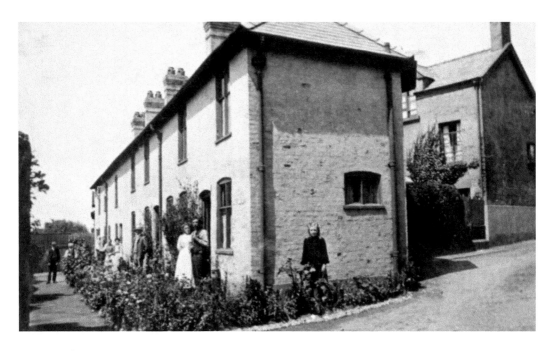

Neston: The Green

When the cholera epidemic struck in 1866, one of the worst hit areas of Neston was The Green near Mill Street. Presided over by a matron and three nurses, two of the nearby cottages temporarily became hospitals. Because of widespread poverty, families instructed to destroy the bedding and clothes of victims were issued with replacements by way of compensation. Despite the death toll, the Health Committee was obliged to step in two years later and instruct tenants of The Green to stop using two nearby middens and an insanitary donkey shed. The cottages above, which were only one room deep, were demolished in the 1960s and replaced with more salubrious dwellings.

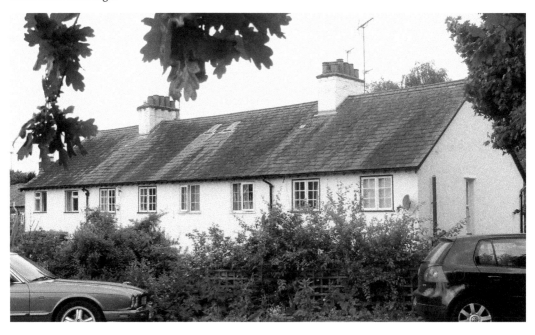

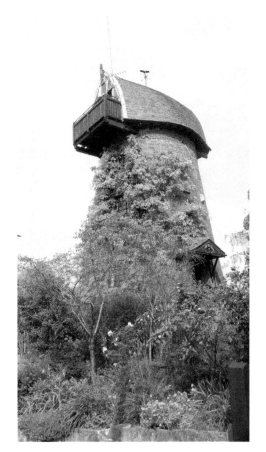

Neston: Old Mill

In the eighteenth century, two mills were built next to each other in Leighton Road. One was badly damaged by a storm in 1822, but the other was used to grind corn until the mid-1880s. Long since reconciled to losing its twin, it became a gallery and glass engraver's in the 1970s until its owner's retirement in 1990. Artfully draped in wisteria, it's now a spectacular private home.

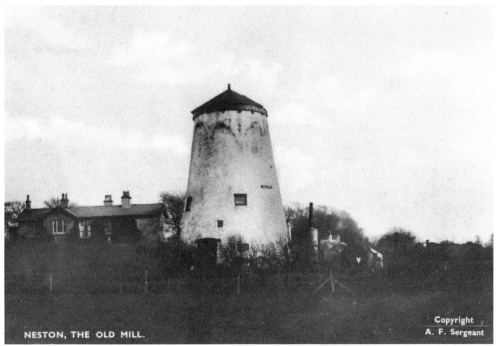

NESTON, THE OLD MILL.

Copyright
A. F. Sergeant

41

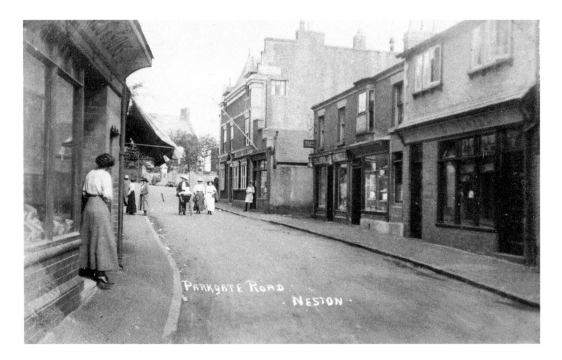

Neston: Parkgate Road

The woman looking towards the Cross in 1906 may be Clara Tranter, who used to run a toy shop in Parkgate Road. Further up on the right is the large pub created from the merger of the Greenland Fishery and the Black Bull. The area between the top of Parkgate Road and the Cross, known as The Rock, was the traditional location of the weekly market. This has been held on Fridays since 1728, when George II granted the privilege by charter. The building beyond it, on the site of today's Tesco Metro, used to be the vicarage.

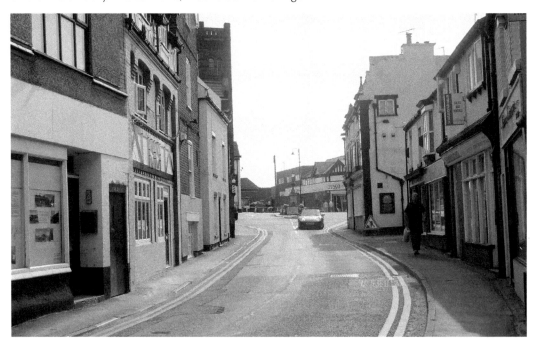

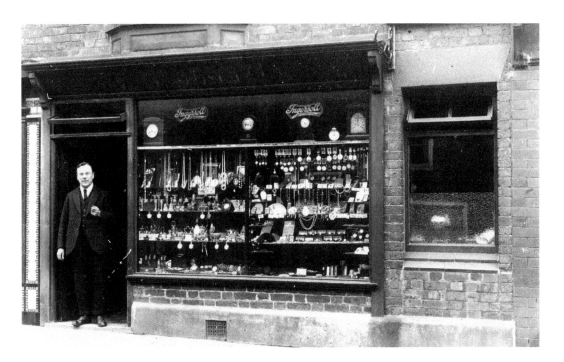

Neston: Parkgate Road

J. McConnell, watchmaker, is shown above standing in the doorway of his shop in Parkgate Road in the 1920s. Nearly a century later, the premises are occupied by Queesra & King, two fashion designers who studied in the North West before honing their skills in London and Paris. They offer a bespoke dressmaking, tailoring and clothes alteration service, as well as wedding packages incorporating photography and cakes. In the 1850s, four tailors and a dressmaker vied for custom in Neston; now most of the competition comes from ready-made clothes.

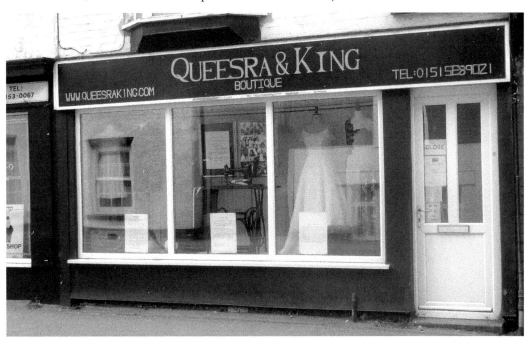

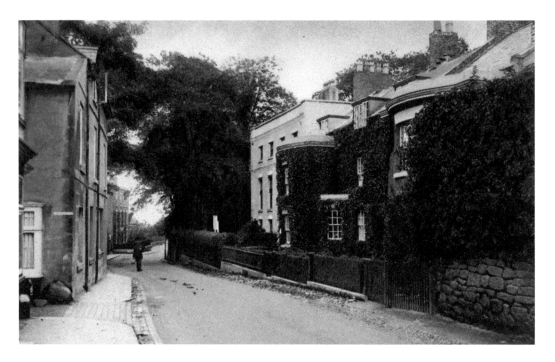

Neston: Parkgate Road

The houses on the right were owned by three generations of the Bond family, all of whom were doctors. The most striking (*inset*) is Elmhurst, built in the early eighteenth century and occupied in 1732 by the first doctor's widow. Its bow fronts and right wing were added later. On its right, obscured by the hedge, is Elmleigh, home of the second doctor, James Bond. The white house on its left is Elm Grove House, dating from 1800 and scandalously sold by the third doctor to the captain of a Liverpool slave ship.

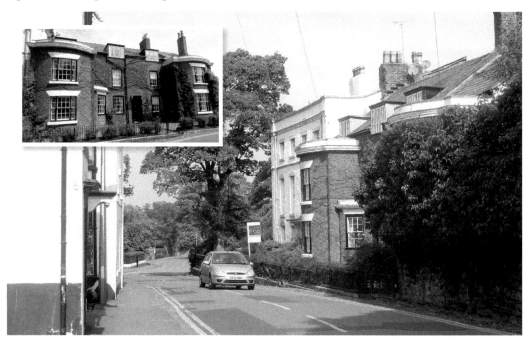

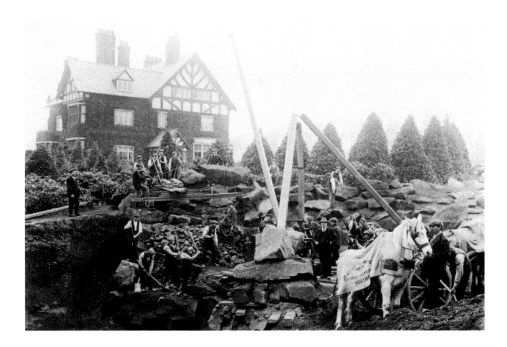

Neston: Leighton Court

Leighton Court was built in 1889 as the home of Liverpool cotton broker George O'Neill. Two years later, he moved out and the house was subsequently owned by William Whineray, a keen huntsman who kept a pack of hounds and owned a quarry in Wood Lane. During the First World War, he ran a munition factory in his garden. The photograph above of local builder Albert Fleming and his team at Leighton Court was taken by Arthur Maycock on 4 February 1914, several months before war was declared. In the 1960s, the house became a casino and country club, but was demolished in 1987 after a fire, making way for an attractive modern close.

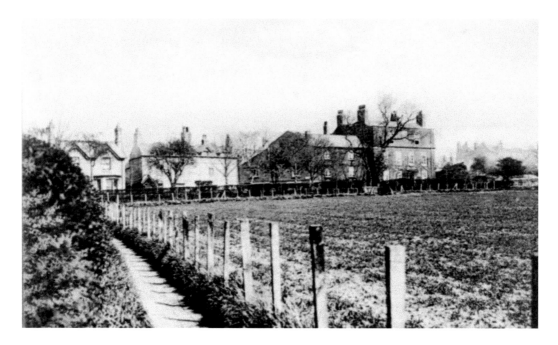

Neston: Library

Leading from Parkgate Road to Old Quay Lane and the Wirral Way, this footpath was known as Doctor's Styles in the early 1900s. The field beside it was owned by Doctor David Russell of Vine House (the tall building on the right, above, and inset, below). He was the local medical officer during the cholera epidemic that killed forty-four local residents in 1866. His widow donated the field to Neston Council when a site was needed for the library, and their son Frank was a partner in Knowles & Russell, the architectural firm that designed it. The field was big enough to accommodate not just the library itself, but also a small garden and car park.

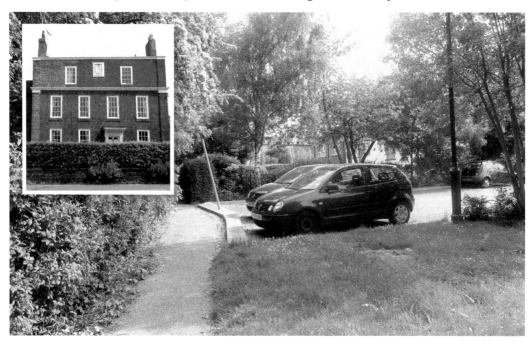

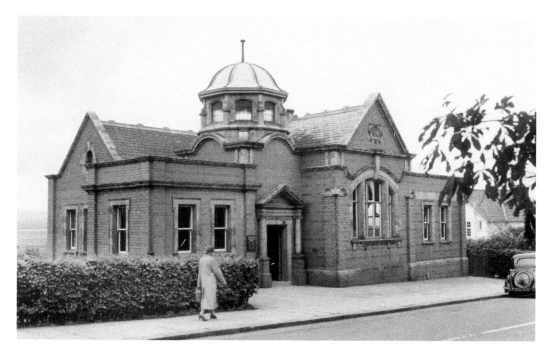

Neston: Library

Built in 1907 as a belated memorial to Queen Victoria, Neston Library was financed to the tune of £1,200 by the Scottish-American steel magnate Andrew Carnegie on condition the site was donated by a local landowner. Despite internal alterations and a rear extension, its frontage has barely changed in the sixty years separating these two photographs. Its opening hours have improved dramatically, however, from a paltry two and a half hours a week in 1908 to more than forty-seven now.

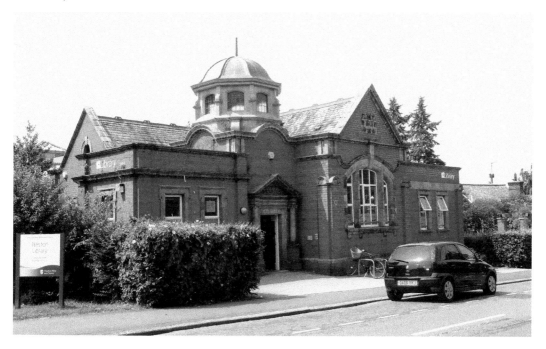

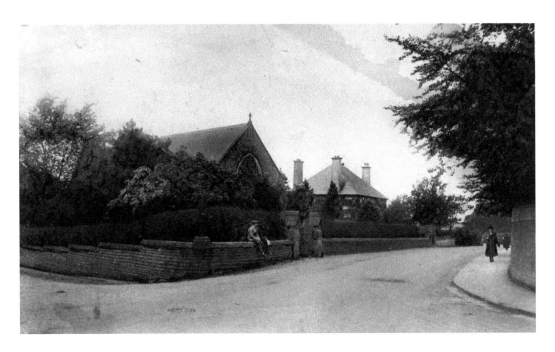

Neston: Presbyterian/United Reformed Church

Neston's Presbyterian church, on the corner of Parkgate Road and Moorside Lane, was opened in 1884, on the site of a chapel where John Wesley, the founder of Methodism, had preached in 1762. It was designed by local architect Francis Doyle, who had already restyled Neston's parish church of St Mary and St Helen, and became Parkgate and Neston United Reformed church after the Presbyterian and Congregational denominations merged in 1972. The planned spire and tower were never built, but the long-anticipated church hall was eventually constructed in 1968. The building on the right is the manse, built in 1900.

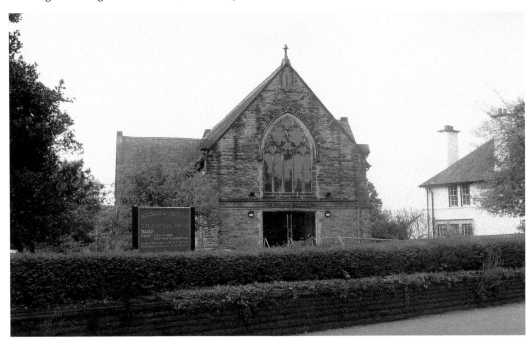

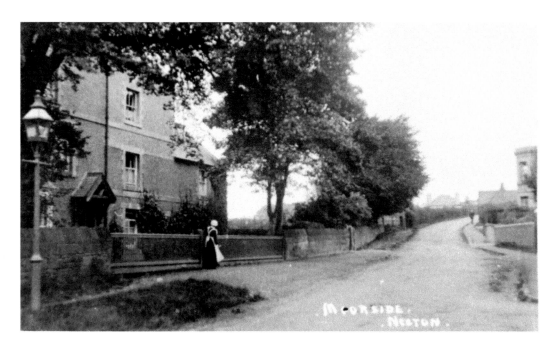

Neston: Moorside Lane

Unlikely as it seems in either photograph, the Moorside Lane area was a centre of education in former years. There was a boys' school situated in Dee House, at the bottom of the lane, from 1822 until the 1850s. A few decades later, two sisters, the Misses McCall, taught twenty pupils at Moorside Private School, which was located in the basement of the Presbyterian church on the corner. Meanwhile, May Richardson's School for Young Ladies, opened at Moorside Cottage in 1913, was so successful, she was obliged to move to grander premises in Parkgate after just five years. Now, only the church still hosts classes and educational activities for adults and children.

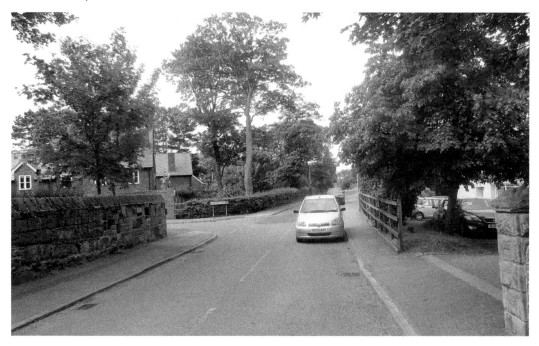

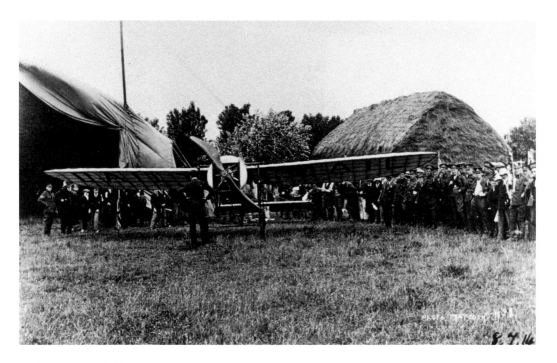

Parkgate: Park Fields

The Hendon-based aviator Henri Salmet (*inset below, centre right*) visited Parkgate for three days in July 1914 as part of a tour organised by the *Daily Mail*. His Bleriot monoplane arrived by lorry, and, taking off from Park Fields, he made over twenty pleasure flights, his first passenger being the headmaster of Mostyn House School (pictured bringing Salmet and another passenger some lunch). Monoplanes may now be in short supply on the makeshift airstrip, but at least the Friends of Park Fields have promoted biodiversity by sowing wildflower seed there.

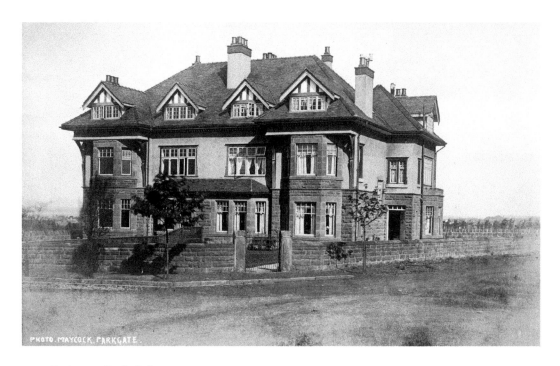

Parkgate: Earle Drive

Earle Drive was created for commuters in 1902 by the Manchester property developer N. A. Earle. Take-up of building plots was initially so slow that before the First World War, Woodhill was one of only two homes to have been built there. No longer in splendid isolation, it still stands near the top of Earle Drive, having been divided into separate dwellings after a stint as a nursing home. Increased demand for accommodation means that spare plots have long been a thing of the past on the tree-lined street.

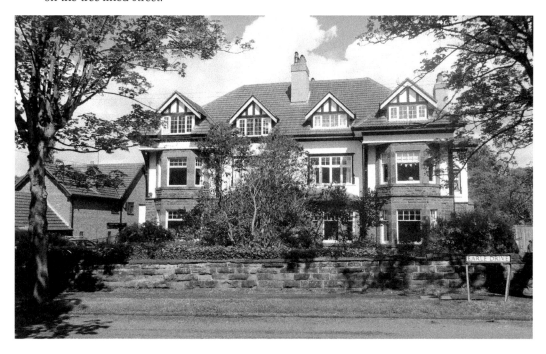

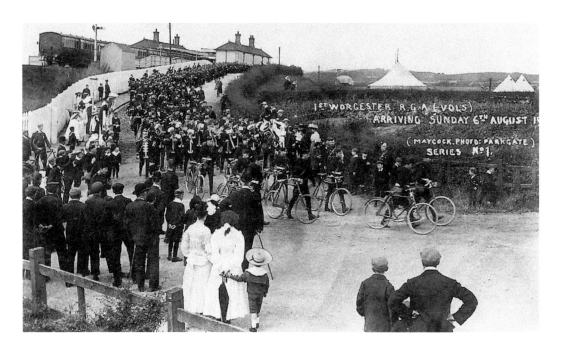

Parkgate: Station

The opening of Parkgate station in 1866 brought increased prosperity to the area, enabling Parkgate's fishermen to sell their catches further afield and bringing day trippers, holidaymakers and commuters, as well as volunteer soldiers on their way to summer training camps. Such arrivals engendered great interest, with cyclists and onlookers turning out in force to greet the First Worcester Royal Garrison Artillery on an August Sunday in 1906. Six years after the railway line's closure in 1962, Cheshire County Council converted it into Wirral Country Park, setting a trend for other disused railways across Britain.

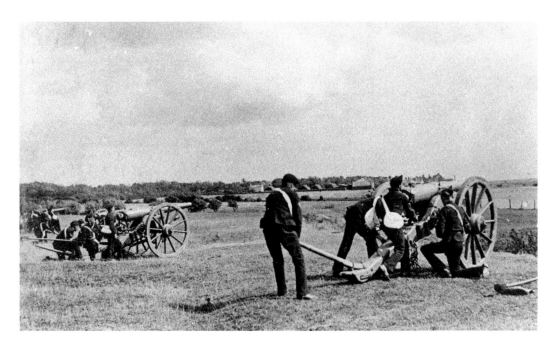

Parkgate: Defence of the Realm

In the wake of the Crimean War, volunteer Army corps were formed from civilians who combined their day jobs with part-time military service. The photograph above shows the First Worcester Volunteers artillery training at Parkgate in 1903. Coastal defence was deemed even more crucial during the Second World War. This concrete pillbox near the Wirral Way is the last surviving remnant of Parkgate's machine gun emplacement. Roughly hexagonal with one longer side, it was designed to be manned by six defence volunteers, each equipped with a Bren gun (a light machine gun) or a rifle.

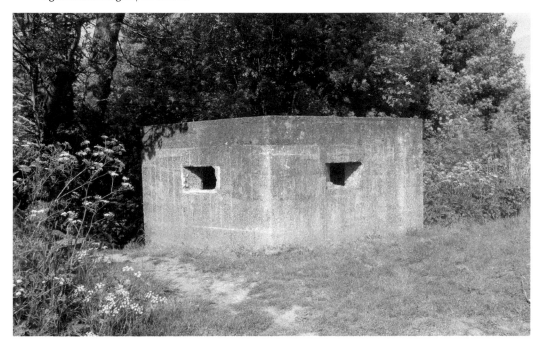

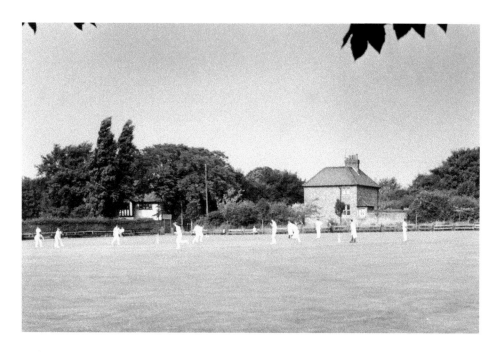

Parkgate: Neston Cricket Club

Despite its name, Neston Cricket Club is actually located in Parkgate, on Station Road. After false starts in 1874 and 1890, the club took off properly in 1895, renting a field from Parkgate resident Reginald Haigh. As well as two cricket pitches and a crown green bowling lawn, it now boasts three squash courts, twelve tennis courts and an AstroTurf hockey pitch. The existing clubhouse was built after the old one burned down in 1971. Its function suite is named after the late Kenneth Cranston, who played cricket for Neston in the 1930s and went on to play for Lancashire and England after serving as a naval dentist during the Second World War.

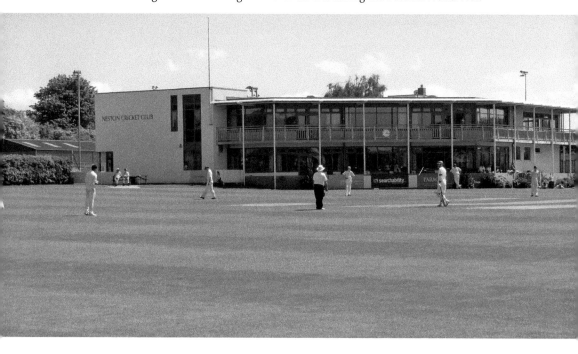

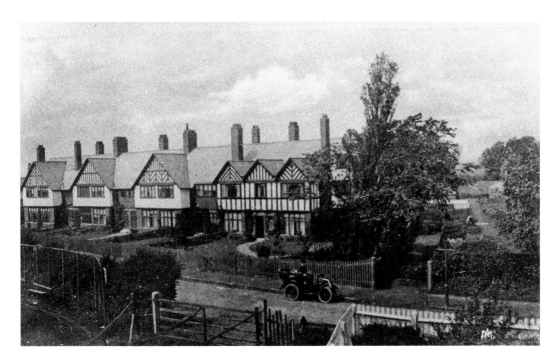

Parkgate: Station Road/Cheltenham Walk

Taken from the station, the photograph of *c.* 1905 shows Dr Lewis Grant in front of his house, No. 6 Cheltenham Place. The car, an 8 hp dark-green de Dion Bouton, was registered as M112 in 1903, and transferred to Henry Fussell of Mostyn House in 1908. Dr Grant moved to Wood Lane sometime between 1910 and 1914. Encroaching vegetation obliged the 2014 photograph to be taken from the Cricket Club instead of the path leading to the former station. The house on the far left now Bramblings day nursery and preschool.

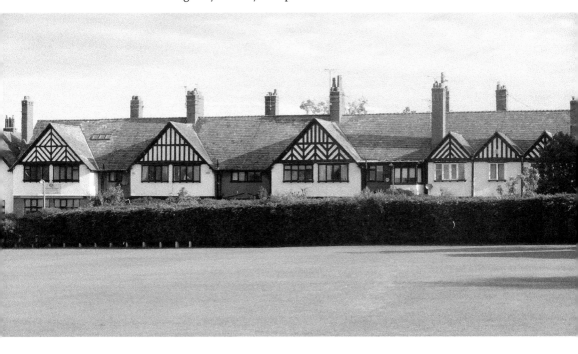

55

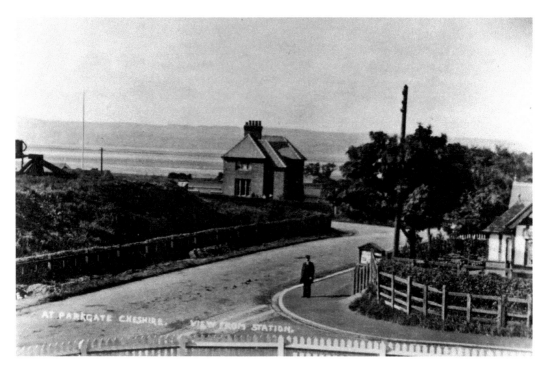

Parkgate: Station Road

The picture above was taken around 1910 by professional photographer Arthur Maycock, whose premises are just visible on the corner. His vantage point from Parkgate Station is now shrouded in trees. The lone building on the left of the road is the stationmaster's house, in a prime location overlooking Neston Cricket Club. The view of the Welsh hills in the distance remains reassuringly unchanged.

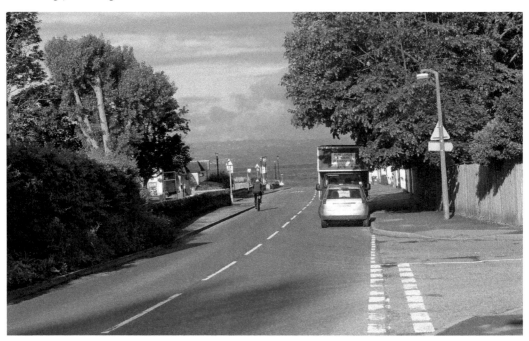

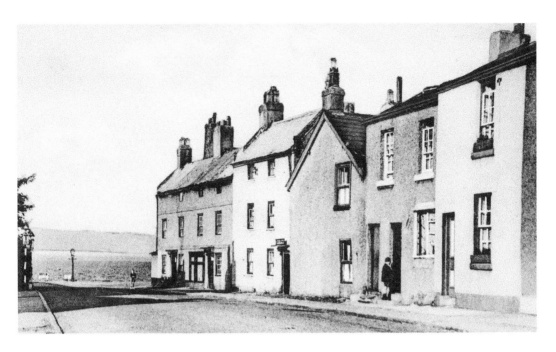

Parkgate: Station Road, 1930s

Most of these cottages were built in the eighteenth century, though one, squeezed into a space that used to be a passageway, is more recent. The future Lady Emma Hamilton lodged at Dover Cottage (the one nearest the river) in 1784 while she was taking the Parkgate waters to heal a skin complaint. By strange coincidence, the name Nelson is set in black pebbles outside the cottage next door. This is not a reference to the famous admiral who became Emma's lover, but a memorial to the drowned son of the Chester miniaturist Albin Burt, who used to weekend in Parkgate in the 1820s.

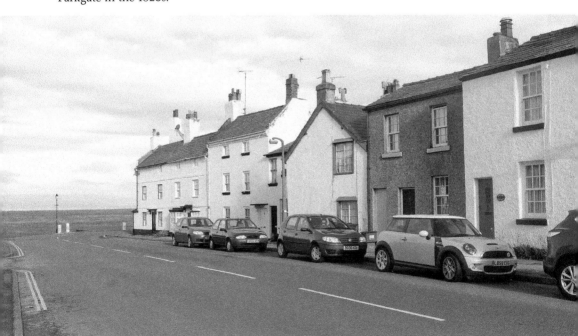

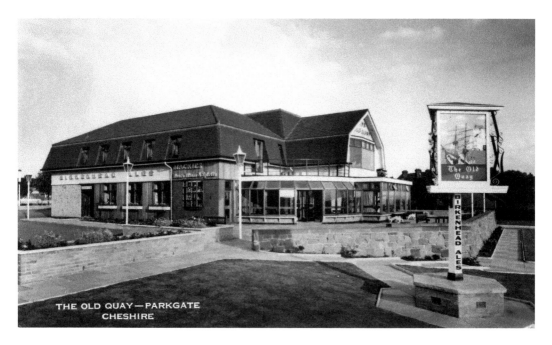

THE OLD QUAY — PARKGATE
CHESHIRE

Parkgate: The Old Quay

The Old Quay was built by Birkenhead Brewery in 1963. Its restaurant was then open for only an hour and a quarter on weekdays and an hour and a half on Sundays, but a satisfied customer confided to friends in Lancashire that it was 'all very posh and lovely food'. It is doubtful whether visitors to Parkgate felt quite so positive about one of the buildings that previously stood on the site. Officers based at the eighteenth-century Custom House policed the cargoes of ships travelling to and from Ireland and inspected passenger's luggage. Smuggled goods were seized and auctioned, with proceeds forfeit to the Revenue.

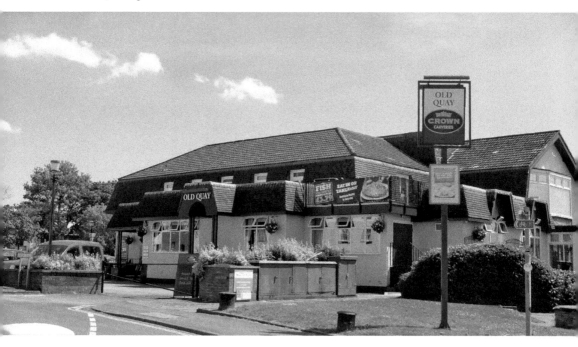

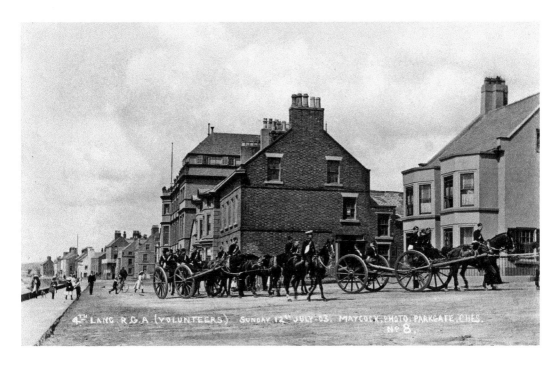

Parkgate: Talbot House and Seaward House

Another of Maycock's photos, this shows the 4th Lancashire Royal Garrison Artillery going past two stunning eighteenth-century buildings in June 1903. Seaward House is the property with bow windows. These were a later addition and are not shown in the architectural plans of 1721. Between *c.* 1870 and 1920, it was boarding school for boys. The Prince Regent's beloved Mrs Fitzherbert reputedly stayed at the other house in around 1798, when it was the Talbot Inn. Its later stint as the Green Shutters Café is commemorated on its letter box to this day.

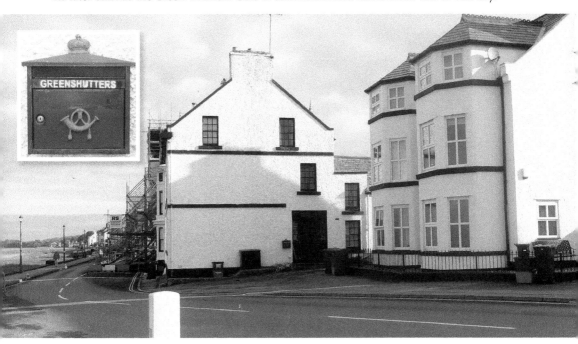

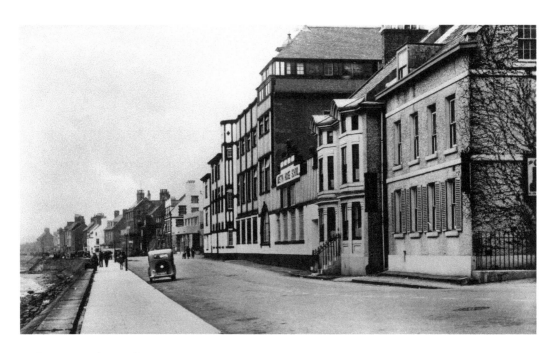

Parkgate: South Parade

When Parkgate first became a port there was nothing separating the houses from the beach – not even a proper road, never mind a seawall. Then, as more and more fashionable visitors flocked to the resort, it was deemed desirable to provide some sort of walkway. The middle section of The Parade was built around 1800, the southern section (shown here) around 1830, and the north end in the 1840s. It has been a popular place to stroll ever since, attracting hordes of day-trippers from Merseyside and Cheshire. The Green Shutters Café (now a private house) can be seen on the corner, and may have been one of the factors which led the sender of the postcard to report on 15 December 1936, 'Am enjoying my holiday very much.'

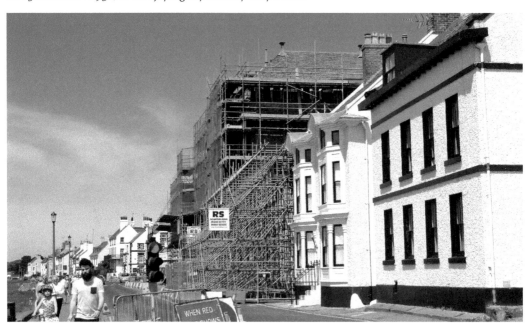

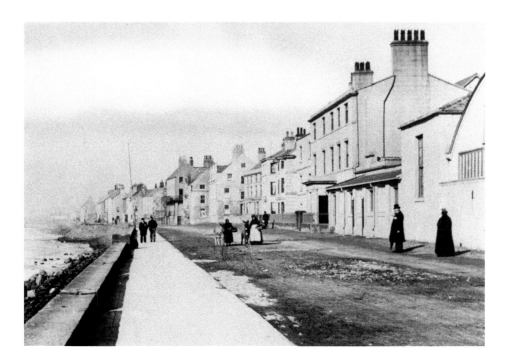

Parkgate: South Parade

In the 1890s, donkeys were a fairly common sight on The Parade. They were expected to earn their keep by pulling cartloads of shellfish and giving rides to visitors. To encourage their owners to keep them in good condition, an animal welfare society held annual donkey competitions, with a thousand people turning up to see the twenty-five entrants at the inaugural event in 1887. The encroaching marsh, snapped on a surprisingly snowy Sunday in March 2013, demonstrates why there is no longer any call for working beach donkeys in Parkgate. Siltation is not all bad!

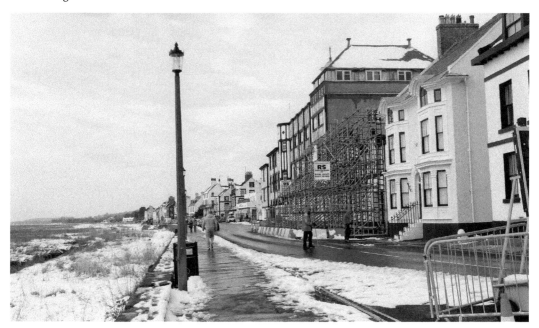

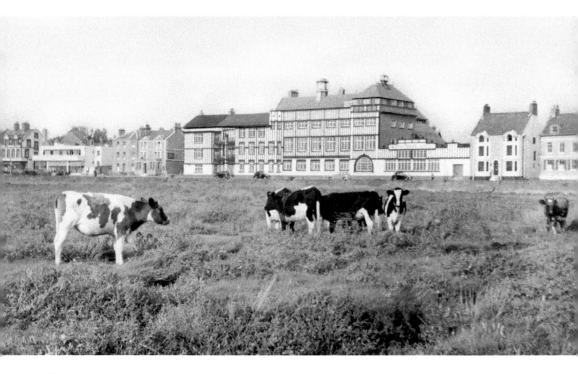

Parkgate: Mostyn House School

In the 1950s, daring farmers allowed their livestock to graze on the marshland, but now treacherous bogs are liable to ambush anyone attempting to emulate the original photographer. The large striped building in the distance is Mostyn House School. Previously based in Tarvin, the headteacher, Edward Price, moved his pupils to Parkgate – then lapped by the tidal waters of the River Dee – in 1855 so they could benefit from the healthy climate. The close up of the school's distinctive frontage was taken in 2013, just before scaffolding hid it from view for months on end.

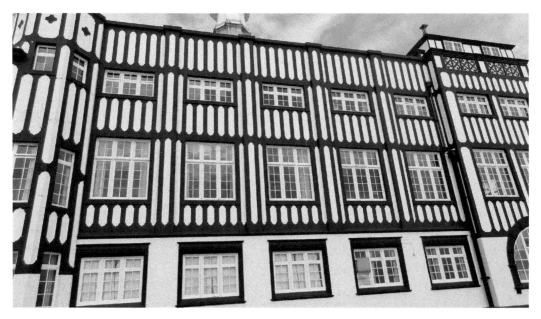

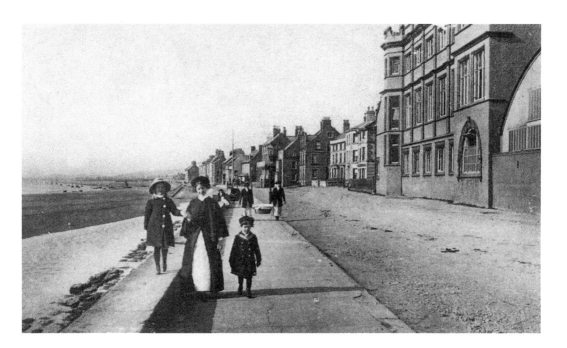

Parkgate: Parade

Mostyn House School had yet to acquire its black-and-white livery in 1916, when this happy trio was taking the air along The Parade. The curious domed structure visible on the left was the school's covered playground, built in 1891. The large central section was finished in 1898, and beyond that the oldest part of the school was an eighteenth-century inn called first the George and then the Mostyn Arms Hotel, after the family who once owned all of Parkgate and most of Neston. When falling rolls led to the school's closure in 2010, the entire complex was bought by a property developer for conversion into flats and houses.

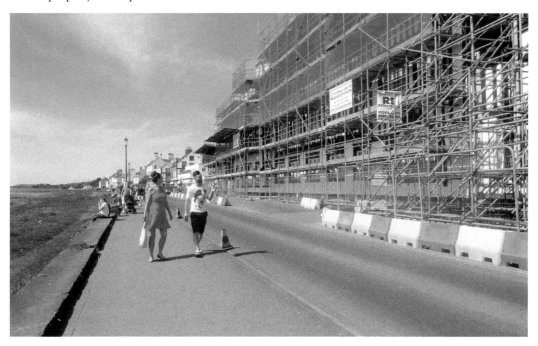

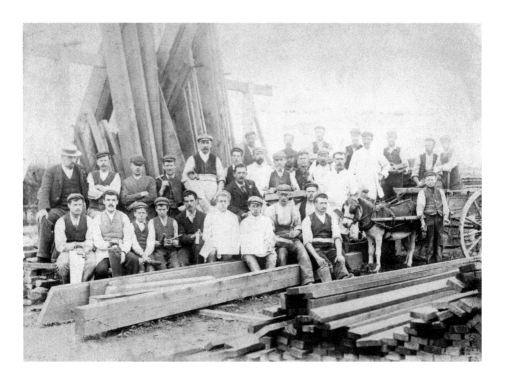

Parkgate: Mostyn House Construction Team

Without doubt, Mostyn House School's most dynamic head was Algernon George Grenfell, one of six generations of the family at the helm during its 155-year history in Parkgate. It was his idea to restyle it in black and white when the eighteenth-century façade needed strengthening, and also to instigate the construction of a chapel and a water tower for an artesian well. No particular safety features were in evidence when his labourers – shown here with timber for the chapel in 1896 – took time out for this photograph, but during the twenty-first century conversions high visibility gear and hard hats are the order of the day.

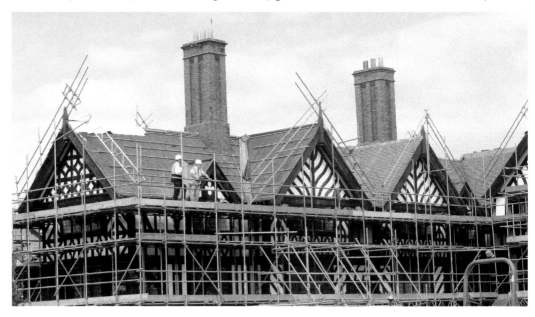

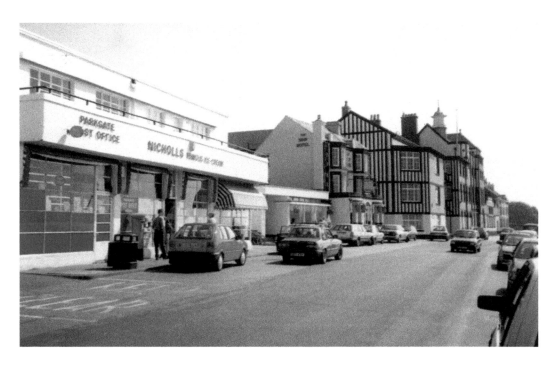

Parkgate: Nicholls' Famous Ice-Cream Shop

Eating an ice-cream while strolling along The Parade is traditionally considered one of the highlights of a trip to Parkgate. The custom took off when a Neston dairyman called William Kingsley Nicholls opened an ice-cream shop in 1937. Management was transferred to Bill Collier in 1988, but the association with the shop's founder lingers in its name. All the ice-creams are still handmade on site to secret recipes, with flavours ranging from black cherry to Turkish delight, cinder toffee and banana chocolate chip.

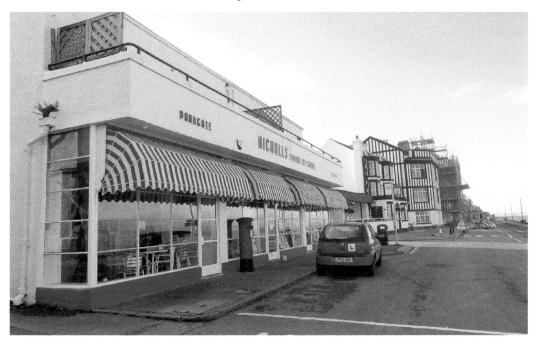

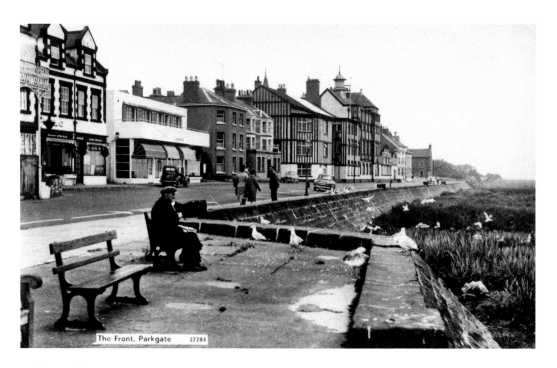

The Front, Parkgate 27284

Parkgate: the Donkey Stand

In the 1780s, this projection into what was once the river and is now the marsh was the site of one of Parkgate's assembly houses. The building was then converted into a seawater swimming pool before being demolished in 1840. At the end of the nineteenth century, children could pay tuppence for a donkey ride from the platform to the southern end of The Parade, hence its current name. In the background, the bow-windowed building between Mostyn House School and Nicholls is a pub called The Ship. It stands partly on the site of the opportunistically named Drury Lane, Parkgate's short-lived theatre zone.

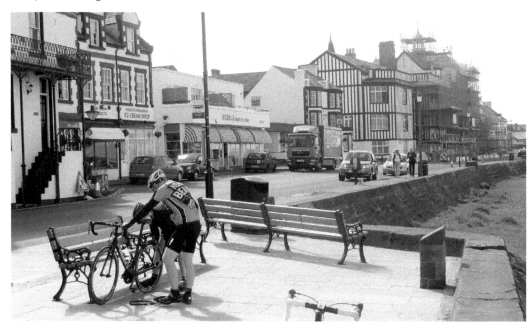

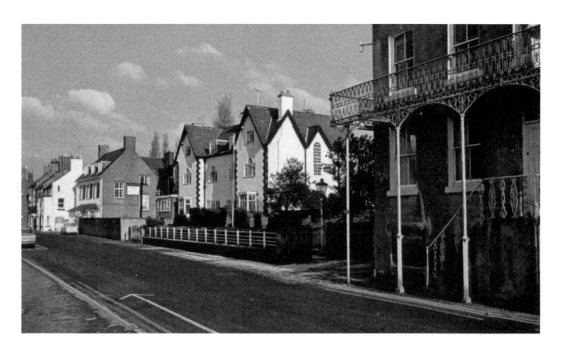

Balcony House

Directly opposite the donkey stand is Balcony House, built around 1750 as two private homes. A large assembly room was constructed at the back thirty years later, and the distinctive iron balconies were added in 1868. In *Kelly's Directory* of 1914, it was rather depressingly listed as a 'Home for Feeble-Minded Girls and Laundry Training', but six years later it was being run as a lodging house for holidaymakers, and the assembly room was divided into changing cubicles for bathers. The cellars were strengthened in the Second World War for use as a public air-raid shelter. The building has now reverted to its original use as housing.

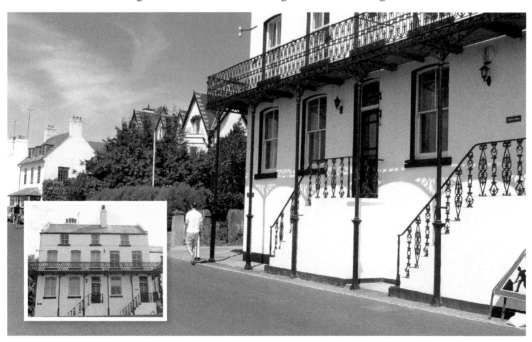

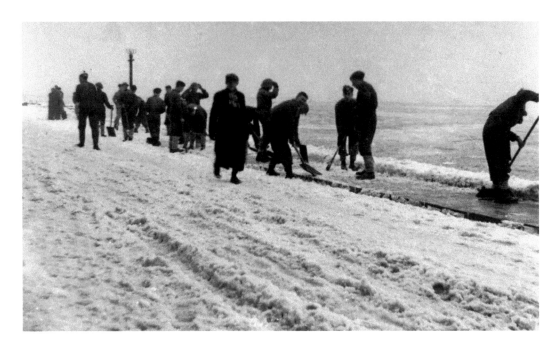

Parkgate: Parade

It can come as a bit of a shock to see snow blanketing somewhere more commonly associated with ice-cream and day trips. These two scenes were snapped in 1941 and March 2013. In the wartime picture above, soldiers are clearing the path – something no sensible civilian would attempt today owing to the vagaries of the tort of negligence. According to English law, if you don't clear a path and someone falls over, it's nothing to do with you, but if you do clear it and they fall, you can be held liable for damages for not doing the job properly. This explains why only the patches hit by sunlight and footprints are clear in the later picture – not that it seemed to diminish The Parade's popularity.

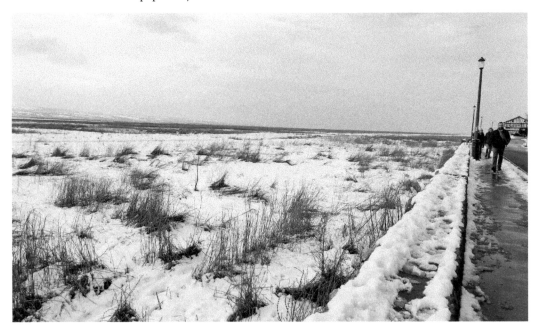

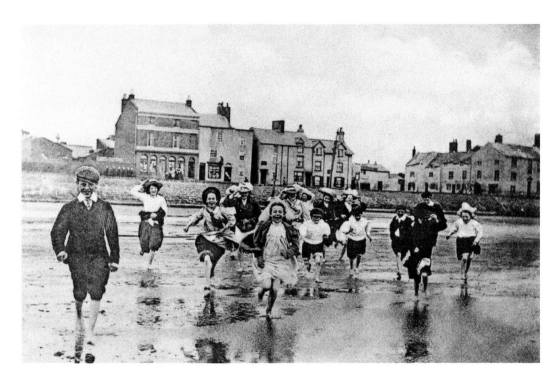

Parkgate: Fun Run

The exuberant *joie de vivre* of these Edwardian children running on the Parkgate sands lived again in the energetic little boy who couldn't wait to sprint along the trampled grass by the seawall on a sunny day in May 2014. Over a century – and half the length of The Parade – separates them, but in spirit they are identical. The beach may have gone forever, but some things never change.

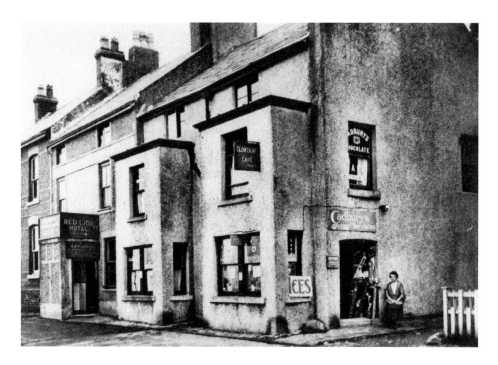

Parkgate: Clontarf Café and The Red Lion

In the foreground of the vintage picture is Clontarf Café, whose enterprising proprietor, William Ledsham, commissioned a photographer to create several postcards of local places to supplement his other business interests. Abutting the café is the Red Lion Hotel, first documented in 1822 and run by the Wood family – Lee Wood in 1850 and John Wood in 1892. Sadly, the Clontarf is no longer in evidence, but The Red Lion is still going strong and hosts a black-tie event every St George's Day.

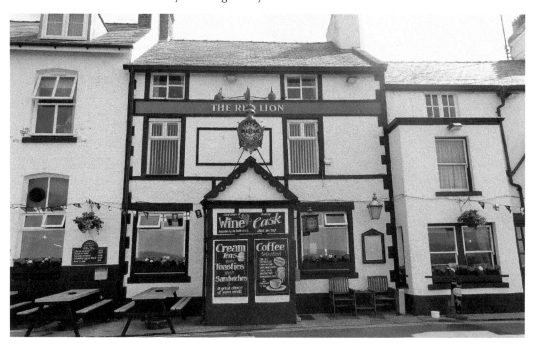

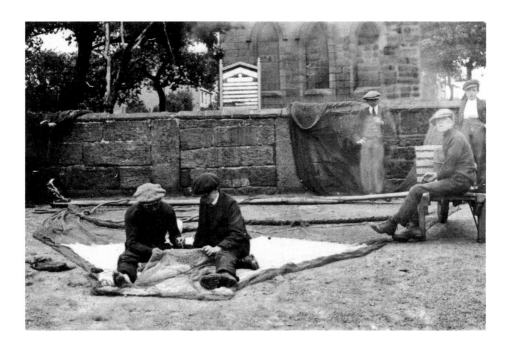

Parkgate: Mostyn Square

How many men does it take to mend a fishing net? In 1918 five, apparently – two to do the work, and three to watch. The building behind them was nicknamed The Fisherman's Church as nets were often hung on the churchyard walls to dry. It was built as a chapel in 1843 by the local Congregationalists, and sold to the Presbyterians in 1858. The Church of England leased it in 1910, bought it seven years later, and dedicated it not to St Peter, patron saint of fishermen, but to St Thomas the Apostle, patron saint of architects. This was clearly an inspired choice: the church became a Grade II* building in 1995, and was sensitively restored with local support in the first decade of this century.

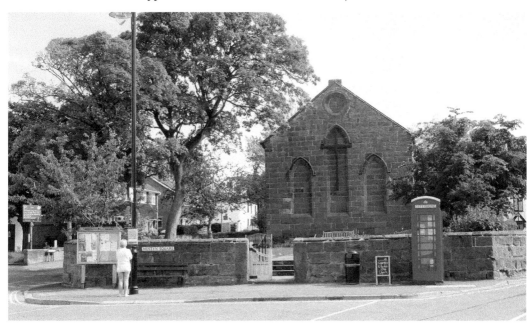

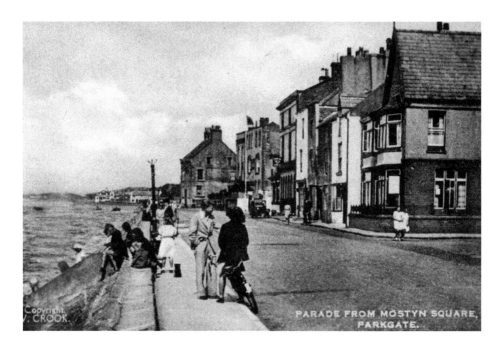

Parkgate: Parade from Mostyn Square

Showing the central section of The Parade from Mostyn Square to Overdee, the above photograph was snapped for a postcard in the 1930s when the tide was high and the clothes looked surprisingly modern. Perhaps because of wartime shortages, the design was still in circulation the following decade, when an enthusiastic visitor sent it to a French lady in London on 18 May 1943: 'We have been over to Parkgate today. Glorious weather and quite a change from Cornwall! Am enjoying the rest and wish I could stay longer.' By contrast, prolonging their progress along The Parade was clearly not on the agenda of the cyclists making the most of the early morning quiet on a May bank holiday in 2014.

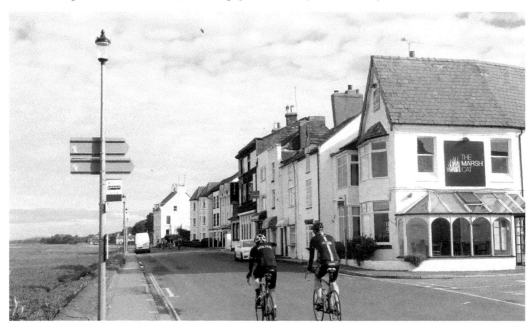

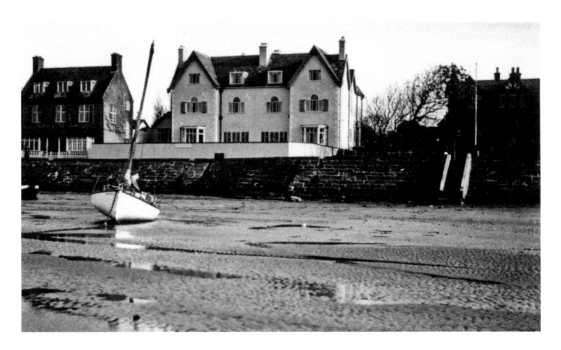

Parkgate: Holywell House/Marsh Cat

'Evolve to survive' could easily be the motto of Holywell House, situated to the left of Mostyn Square. It was built as a pair of pleasingly symmetrical villas in 1863 on the site of a spacious house that was no longer considered fashionable. Fifty-five years later the villas were merged to form Holywell Hotel before becoming the North West's first residential home for elderly diabetics in 1948. After undergoing extensive alterations, the left side was subsequently split into two houses, while the right side is a restaurant called The Marsh Cat. The name is reputedly derived from a legend about the ghost of a ship's cat who perished on a crossing to Ireland and now wanders The Parade and marshes, searching for the best meal.

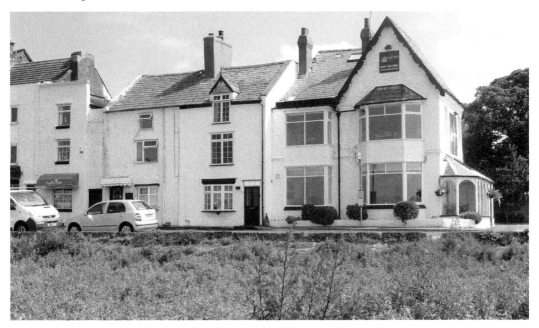

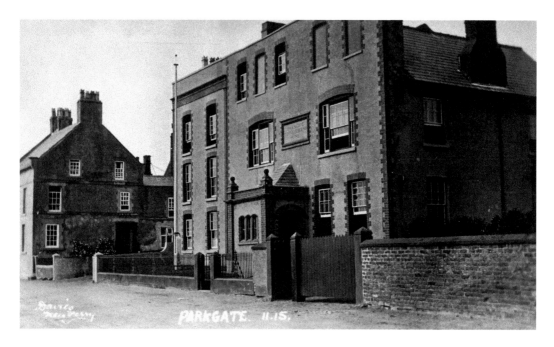

Parkgate: Convalescent Home

In the eighteenth century, people believed that invalids would recover faster in healthy sea air. The Parkgate Sea Bathing Charity, created in 1790, accordingly used the building in the foreground to accommodate impoverished patients, who could stay for three weeks at the charity's expense. In 1882, ownership passed to Chester Royal Infirmary, and the home became a haven for wounded soldiers during the First World War. After being sold in 1923, it was was used first as a holiday home for underprivileged children and then as a refuge for wartime evacuees. Shored up for decades by its rectilinear façade, it was demolished in the 1950s. Now the site is occupied by Deeside Court, sheltered accommodation in pastel tones reminiscent of Parkgate ice cream.

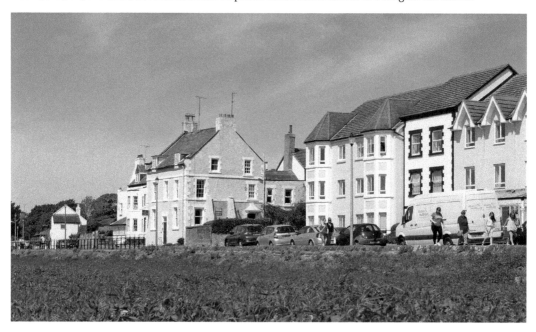

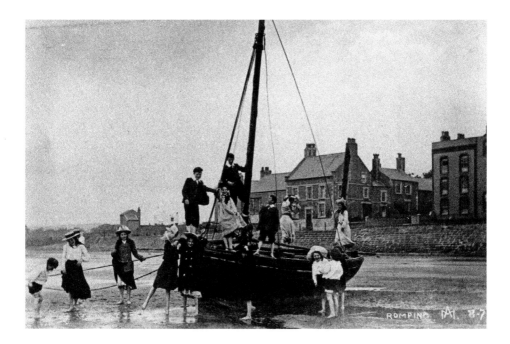

Parkgate: Boats

Two types of fishing boat were favoured in Parkgate: two-masted jiggers and single-masted nobbies, which had shallow draughts particularly suited to coastal rivers like the Dee. Although usually needed for work, the boats were also a source of fun at the beginning of the twentieth century – and not just for children. The annual Fishermen's Regatta took place in either June or July – whenever the tides were most auspicious – with separate races for nobbies and jiggers and a cash prize for the winners. The only boat in evidence now is this quirky model, placed by accident or design almost exactly where the nobby was ambushed by children over 100 years earlier.

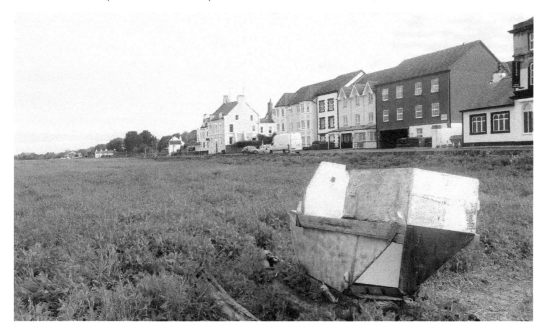

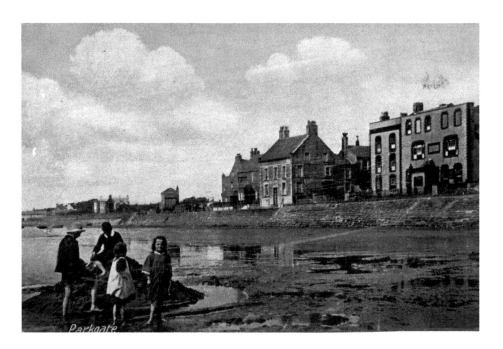

Parkgate: Shore

Sent after a 'good day's outing' in 1916, the hand-tinted postcard bearing the above image shows Parkgate in the days when it still had a sandy beach. Now it is impossible to stand in the same spot as the original photographer because of the water channels cut into the marsh. These were dug as part of a marshland management process to combat stagnation and reduce the mosquito population by shrinking its breeding grounds. The Convalescent Home and Overdee can be seen in the background. Overdee, with the distinctive configuration of windows on its gable-end, was built in the eighteenth century. Just inside the front door is a short flight of stairs – an important countermeasure against floods in bygone days.

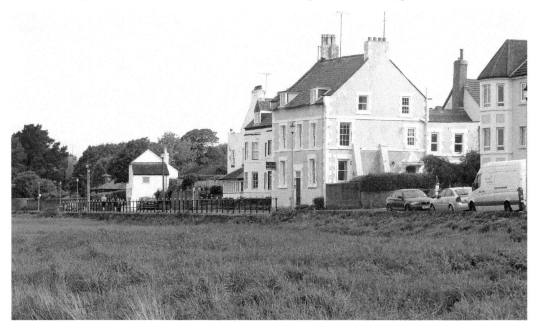

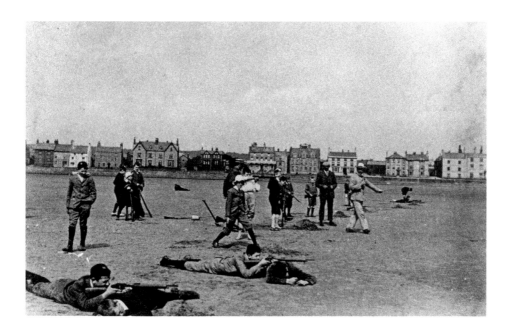

Parkgate: Sands and Marsh

Possibly inspired by the volunteer artillerymen whose annual summer camps were held at Park Fields, Parkgate Rifle Club was formed in 1905 and a rifle range was set up on Manorial Road in the 1920s. Before that, when the tide was out, the sands were considered the ideal place for target practice. Then, apart from occasional spring surges, the tide went out more or less permanently. Non-native spartina grass, planted at Connah's Quay in the 1920s to stabilise the mud banks, spread across the estuary, reaching Parkgate in the late 1940s. Interspersed with plants like seaside centaury and sea aster, it has created an ideal breeding ground for lapwings, oyster-catchers and redshanks, transforming the barren sands into a wildlife haven. Shooting is off the agenda.

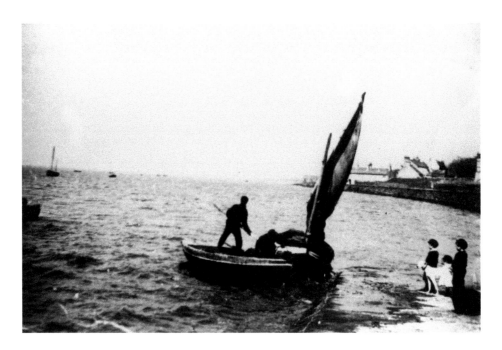

Parkgate: Fishing at the Middle Slip

When their services were no longer required by the shipping trade, local residents turned to fishing, and Parkgate was particularly renowned for its potted shrimps. Nevertheless, in the days before refrigeration, eking out a living was often difficult, particularly when easily preserved herring stocks plummeted. Matters improved when the market widened after the coming of the railway, enabling flatfish and shellfish to be sold further afield while still fresh. With such an expanse of water spread ahead, the children standing on the Middle Slip in the 1890s could surely never have envisaged that one day the area would be swamped by spartina, spelling the end of Parkgate's fishing industry.

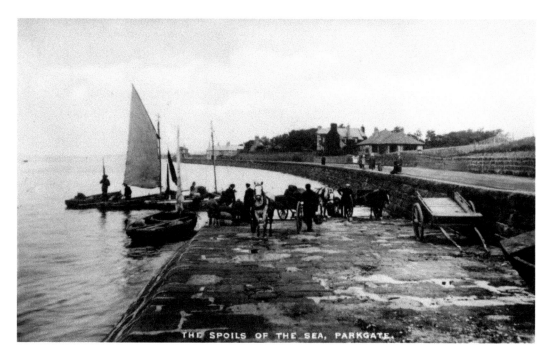

Parkgate: Loading Catches at the Middle Slip

The Middle Slip was used by fishermen in preference to the docking points at either end of The Parade. Traditionally, the daily catch was collected in carts drawn by donkeys, but by the 1940s the long-suffering animals were pensioned off when lorries began taking fish to the railway station and the Mersey ferry for onward transportation. Taken barely a decade apart, these two pictures illustrate not just the enormous effect the tide had on the level of the Dee, but also a turning point when lifestyles changed forever

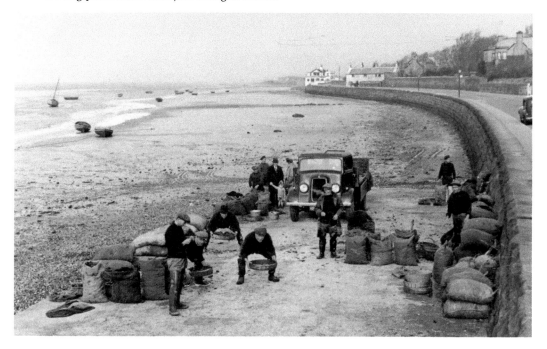

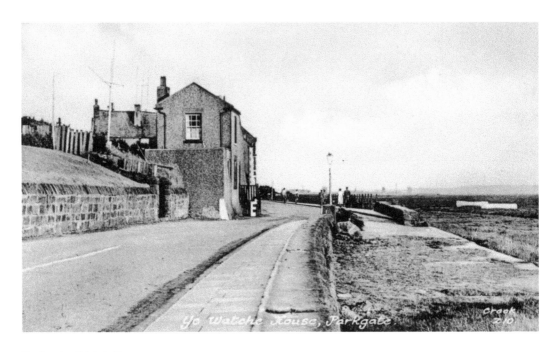

Parkgate: Watch House

When the Watch House was built in the 1720s it had only two rooms, one on top of the other, linked by an external staircase. It was leased by the Board of Customs in 1799 in a bid to crack down on smuggling at the northern end of the shore. Its lofty construction also made it an ideal vantage point for monitoring the treacherous shifting sands. Jutting out into the road, it automatically obliges traffic to slow down, which would have increased its effectiveness. When the customs officers moved out in 1828, Mary Cunningham, bath-house keeper, took over the lease and it has been a private home ever since.

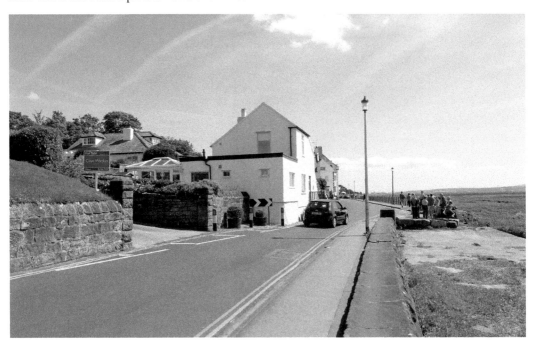

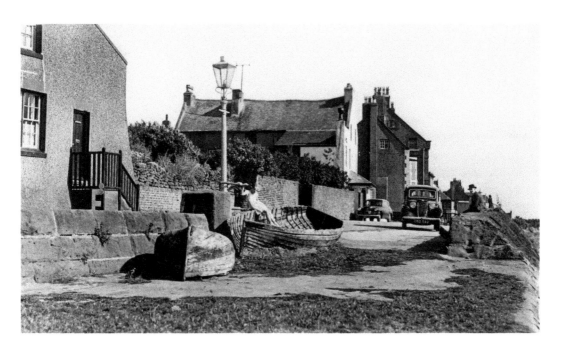

Parkgate: Middle Slip

This angle shows how close the Middle Slip is to the Watch House, whose raised entrance was an essential feature in a spot once prone to flooding. Local artist John Pride stayed there as a seven-year-old, waking in excitement in 1884 to find the house cut off on three sides by the tide. His line drawings of Parkgate were turned into postcards in the 1930s and are now very collectable. The building beyond, with its gable unusually facing the shore, is The Moorings, and was formerly known by the Manx name Moaney Moar, meaning Moor House. After the decline of the fishing industry, boats lay abandoned on the slipway for years, and it has now been blocked off by sandstone boulders.

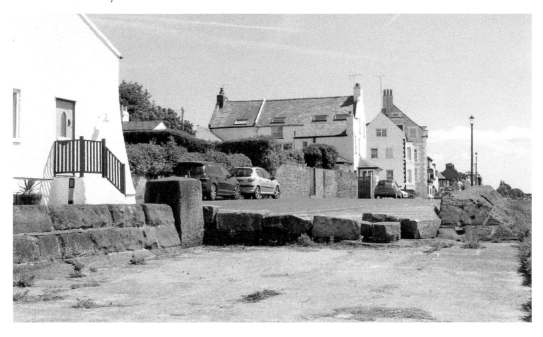

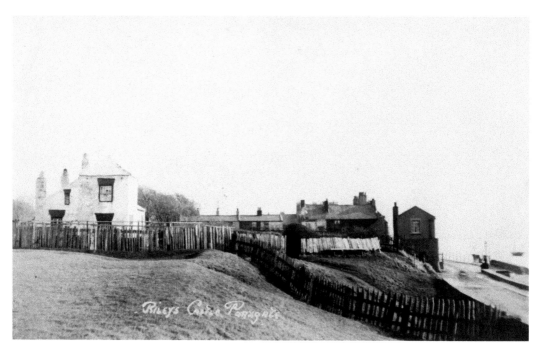

Parkgate: Ryley's Castle

Samuel Ryley (*c.* 1756–1837), a perpetual debtor who eloped to Gretna Green with his employer's daughter, ran a theatre company in Parkgate and wrote a nine-volume autobiography, referred to his whitewashed home as a 'cottage of content'. However, its motte and bailey formation – clearly visible in this photograph of 1906 – led to it being more grandly nicknamed Ryley's Castle. Parts of it are said to survive in the fabric of The White House, built on the site in the 1920s. The Watch House can be seen in the background.

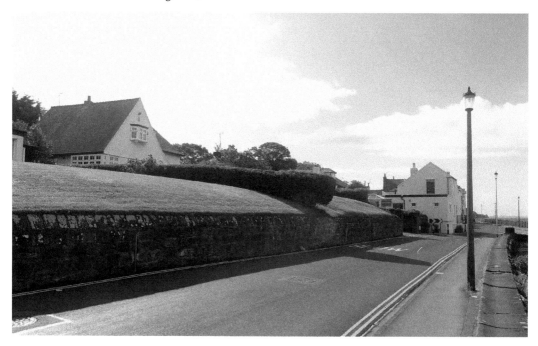

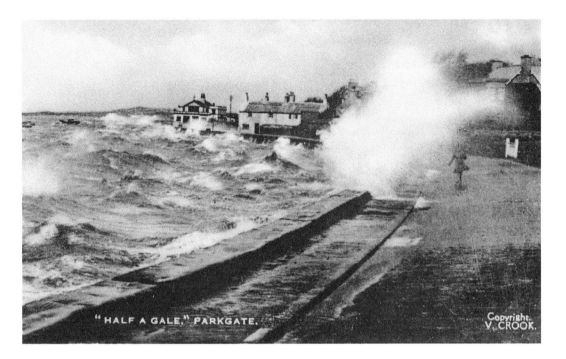

"HALF A GALE," PARKGATE.

Copyright.
V. CROOK.

Parkgate: North Parade

Just to prove that global warming isn't always responsible for extremes of weather, here's a picture of the North Parade in the early 1930s, when the wind was whipping the waves into a frenzy and sending arcs of sea water on to the foolhardy pedestrian determined to go about her business regardless of a wetting. On a halcyon day in 2014, with a gentle breeze shushing through the marsh, it barely seems credible that this could be the same place. Only Dee Cottages and the Boat House Café in the distance stand witness to the truth.

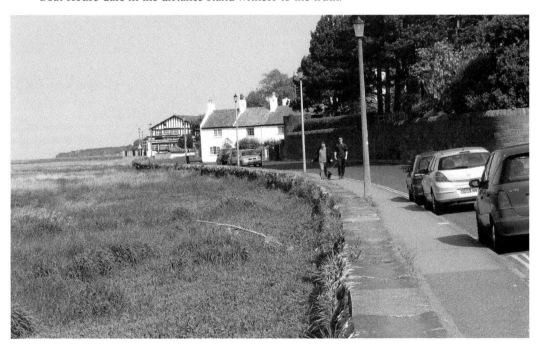

Parkgate: Dee Cottages

Now picturesquely restored and highly desirable, Dee Cottages, on the right, were renowned in the nineteenth century for being permanently damp and prone to flooding. After a storm in 1802, one elderly inhabitant was allegedly drowned in her bed. The cottages currently enjoy Grade II* status – small comfort for the original occupants. The building in the distance stands on the site of an inn called the Pengwern Arms, after one of the Welsh estates of the Mostyn family, who owned practically all the property in Parkgate until 1849.

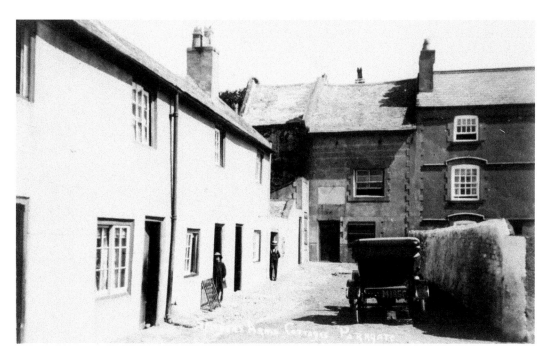

Parkgate: Sawyer's Arms

The narrow building at right angles to Dee Cottages is the Sawyer's Arms, named after its original landlord, Richard Bartley, who was a carpenter as well as a publican, and at the helm *c.* 1793 to 1822. The pub's licence was permanently withdrawn in 1905 as part of a national campaign to reduce drunk and disorderly behaviour, and the building returned to its original use as a private dwelling. During alterations in 1960, a coin dated 1694 was found in the wall. Pengwern, the grander house adjoining it, was built at the same time, its name echoing that of the nearby inn.

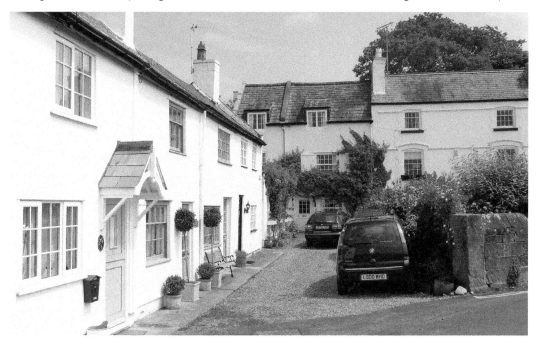

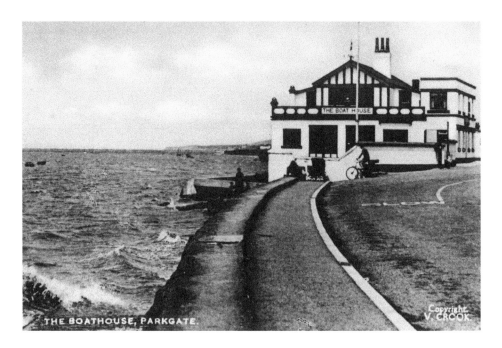

THE BOATHOUSE, PARKGATE.

Parkgate: Boat House Café

The Boat House Café was built in 1926 at the instigation of AG Grenfell, the head of Mostyn House School. Its name was no accident, and nor was its boat-shaped footprint (more clearly visible in the pictures opposite). The spot on which it stands has a long association with watercraft, being situated in the seventeenth century beside an anchorage 8 fathoms (48 feet) deep. To service the vessels which moored there, storerooms and a beerhouse were built, and the shore outside the gates of Neston Park became the original hub of Parkgate. The 1664 beerhouse began to be called the Boat House and the Ferry House when it became the embarkation point for ferries across the Dee to Flintshire between *c.* 1740 and 1864.

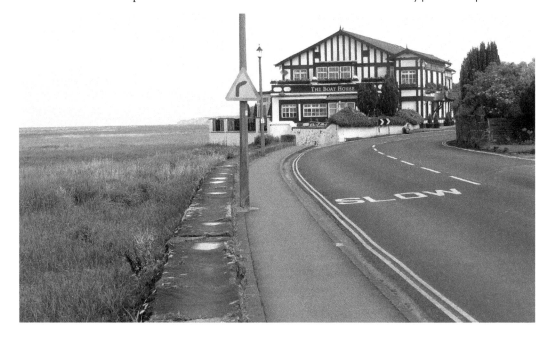

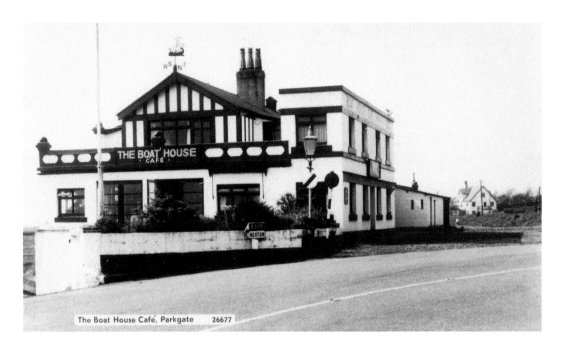

The Boat House Café, Parkgate 26677

Parkgate: Boat House Café

The beerhouse was succeeded by a coaching inn, the Pengwern Arms, taking passengers onwards to Birkenhead, Hooton and Chester. Storm damage led to its demolition in 1885, twenty-one years after the ferry service stopped operating, and it took more than forty years – and the ever imaginative eye of AG Grenfell – for the site's potential to be recognised. Featuring the trademark black-and-white timbering he favoured, the Boat House was enlarged to incorporate a restaurant in 1977 and now entertains its patrons with regular music nights featuring The Parade Jazz Band and other acts.

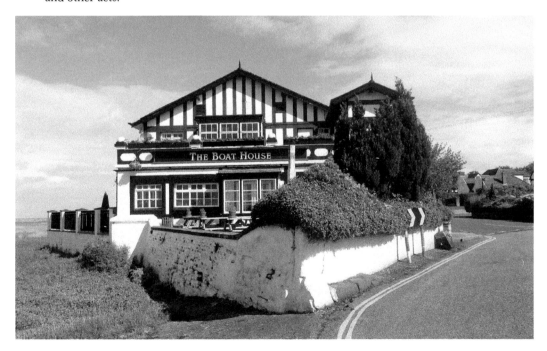

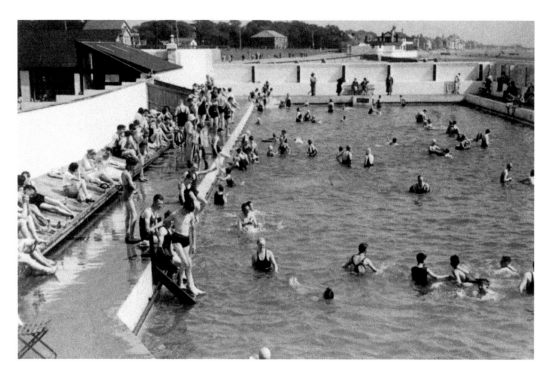

Parkgate: Baths

Beyond the Boat House Café, Parkgate's open-air swimming baths – another enterprise of AG Grenfell, the indefatigable head of Mostyn House School – opened in 1923. The pool was ingeniously designed to be cleaned and replenished by the twice-daily tides, but when siltation affected the depth of the river an artesian well was used to top up the pool's water level. A shallower pool for learners was added seven years later. Lessons were given by Olympic swimmer Hilda James, whose father managed the baths, and for the first time ever schools in Parkgate, Neston and Heswall added swimming to the timetable.

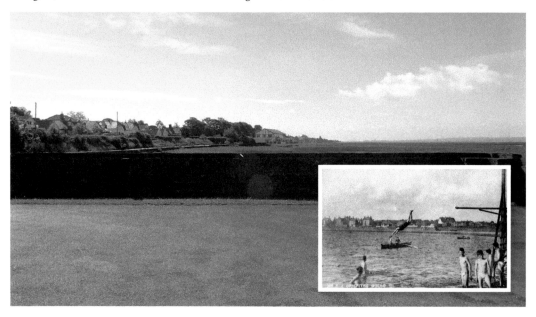

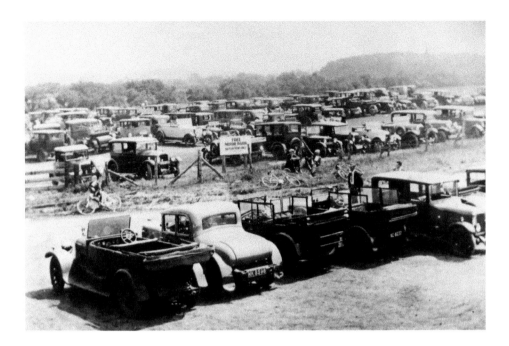

Parkgate: Baths

Keen to increase his male clientele, Grenfell once wrote a spurious letter to a local newspaper, pretending to be outraged by the number of scantily clad women at the Baths. The success of his strategy can be gleaned from the number of vehicles in the baths' car park, which has now reverted to pastureland. In 1939, Grenfell's son, who had taken over as head of Mostyn House School, sold the baths and used the money to pay for a large air-raid shelter equipped with bunks – a wise move, since it enabled the school's pupils to sleep comfortably during the Liverpool blitz. The baths reopened for two seasons during the war and properly in 1947, but succumbed to dereliction after closing in 1950 and now form a car park for the Wirral Way.

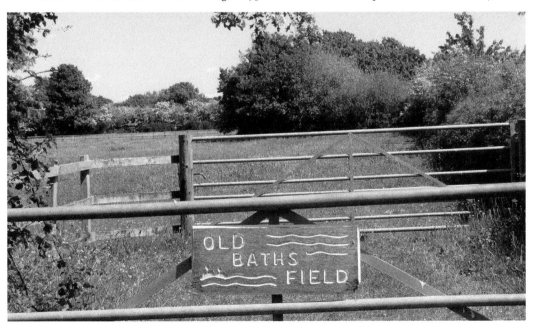

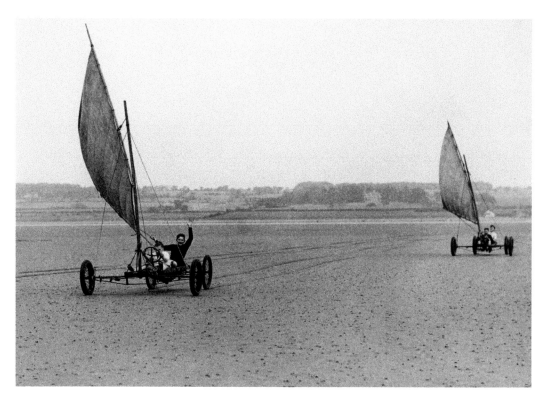

Parkgate: Fresh Air and Exercise

In his effort to keep his pupils active, healthy and enthusiastic about school life, AG Grenfell introduced yacht racing on Parkgate sands. The gleeful winner of this heat in 1928 was clearly enjoying himself, but sadly the sport was yet another casualty of Parkgate's changing shoreline. Running along the lane near Grenfell's Boat House may be a suitably energetic tribute to one of Parkgate's most influential residents, but it hardly compares in excitement...

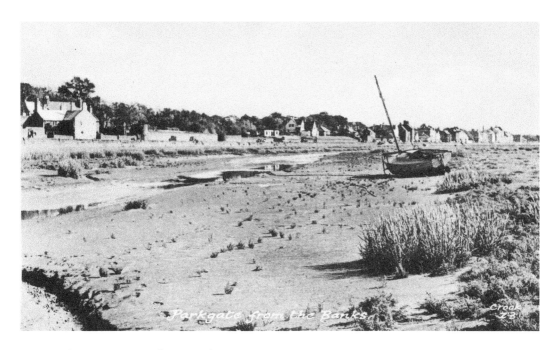

Parkgate: From North to South

This perspective from the edge of the sand/marsh by the Boat House, shows the white gable of Dee Cottages on the left, with the successor of Ryley's Castle and the Watch House further down and Mostyn House School in the distance, identifiable in the 2014 photograph by the green protective netting over the renovations. The image of the beached boat evokes mixed emotions in Norma Clarke, recalling a day trip to Parkgate in the 1950s: 'I lost three sixpences in an old submerged rowing boat tied up there. They must be at the bottom of it now and someone in centuries to come will find my hoard. My pocket money!' Luckily, her auntie bought her an ice-cream and all was well again.

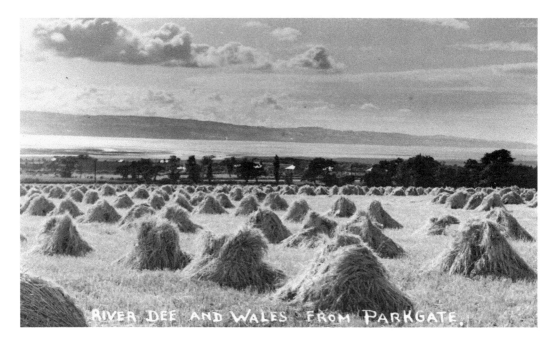

RIVER DEE AND WALES FROM PARKGATE.

Parkgate: Across to Wales

In the early twentieth century, haycocks drying in the summer sun were a common sight in rural communities. Used as fodder and bedding for livestock, locally grown hay was particularly important in the days when horses were more common than cars and transporting bulky perishable goods was too troublesome to be worth doing long distance. Cutting and stacking the hay was back-breaking work, but being able to look across the Dee to the Welsh coast must have been some compensation. Now this area of Parkgate has been set aside for public use, and picnic benches offer a welcome respite for walkers.

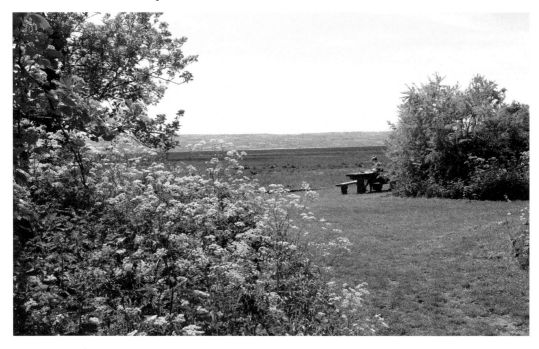

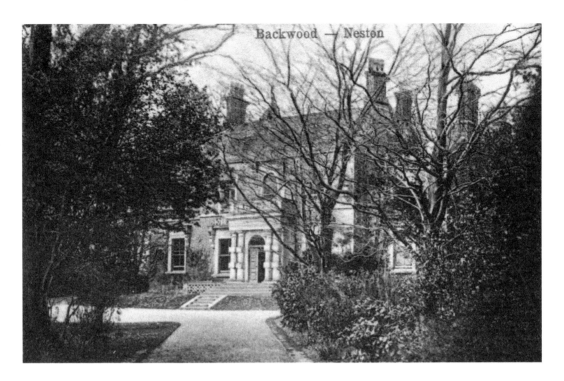

Parkgate: Backwood Hall

Carved above the centre gable of Backwood Hall are the arms of the locally prominent Glegg family, which commissioned its red-brick construction in 1840. Tuscan engaged columns flank the front door of the Jacobean-style Grade II* building, and just visible beyond the balustrade is the pyramidal roof of the square tower at the back. The 300-acre estate's hayloft and bull pen have been converted into holiday cottages, and the livery yard, tennis and paintballing facilities are soon to be joined by the show room of Sandra Harris Interiors.

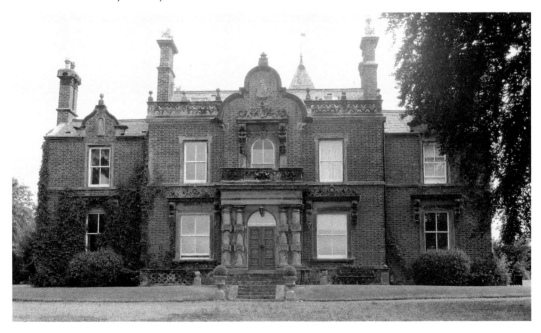

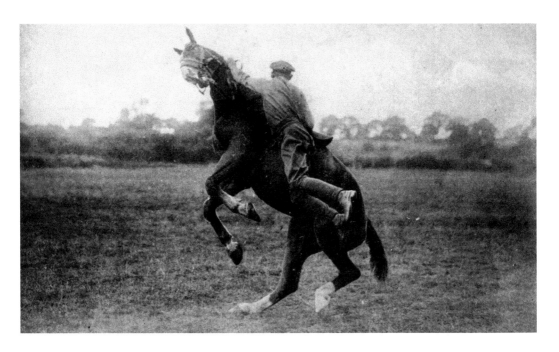

Parkgate: Equine Exploits

'Mankillers converted' proclaimed the advertisements of Lt Mike Rimington, who ran a riding school and horse reformatory at his stables in Station Road in the early twentieth century. His determination to subjugate horses to his will looks rather drastic, but he was reputedly a horse whisperer who didn't use riding crops or whips, and his methods were certainly appreciated by the men who travelled round Britain, requisitioning horses to serve at the front during the First World War. Today, life couldn't be more different at Parkgate Pony Sanctuary in Boathouse Lane, where friendly Shetland ponies fearlessly canter towards complete strangers in confident expectation of treats, praise and pats – no training required.

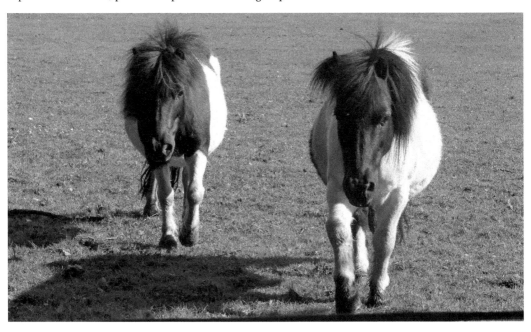

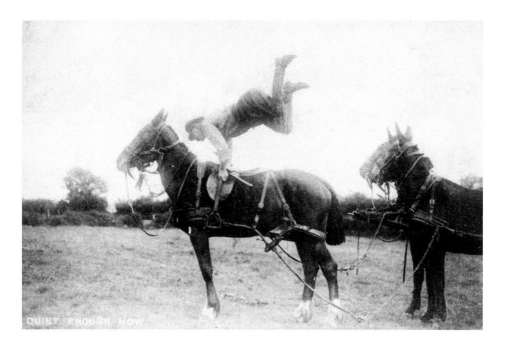

Parkgate: Happy horses?

Rimington's skill was known far beyond English shores. He had served as a cavalryman with the 37th Lancers during the Boer War, and was credited with saving the lives of dozens of previously untameable horses who would otherwise have been destroyed. 'He understood horses, and, apparently they understood him,' one witness was quoted as saying in a Canadian newspaper in 1916. Rimington even starred in a film entitled *Reforming Army Outlaws*. Nevertheless, doing acrobatics on a horse that was hitched to two others hardly seems a humane activity from a twenty-first-century perspective. How much better to crop the grass while tenderly protected from the sun's rays by a specially designed white blanket.

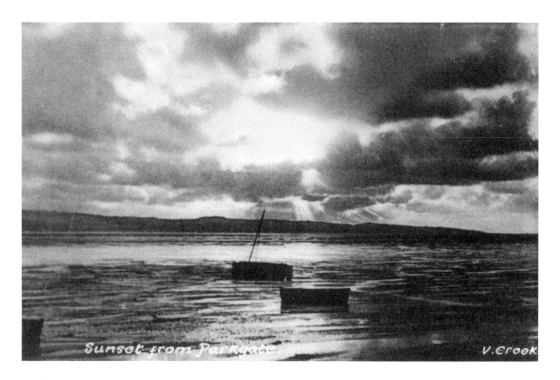

Parkgate: Sunset Over Parkgate

Two sunsets snapped roughly eighty years apart encapsulate the story of Parkgate from coastal settlement to wildlife haven. The expanse of water above typifies the settlement's past. The marshland below is the present and the future. What more is there to say? Wales lies on the horizon. Water shimmers in the dying rays. And the sun will rise in the morning.

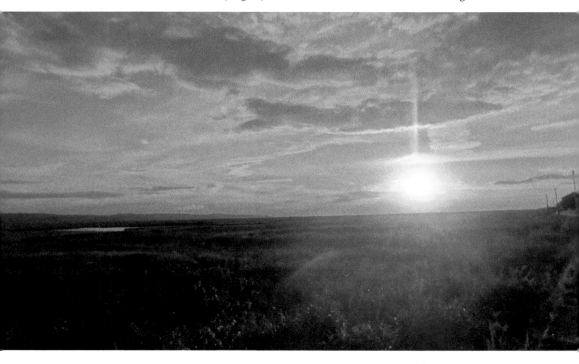